Franciscan Dining Services

Jeffrey B. Snyder

Dedication

To Madeline, the newest light in our lives.

Library of Congress Cataloging-in-Publication Data

Snyder, Jeffrey B.
 Franciscan dining services / Jeffrey B. Snyder.
 p. cm.
 Includes bibliographical references and index.
 ISBN 0-7643-0158-6 (pbk.)
 1. Franciscan ware--Collectors and collecting--Catalogs.
2. Pottery--20th century--California--Catalogs. 3. Gladding,
McBean and Company--Catalogs. I. Title.
NK4340.F68S67 1996
738.3'7--dc20 96-21631
 CIP

Published by Schiffer Publishing Ltd.
77 Lower Valley Road
Atglen, PA 19310
Telephone 610-593-1777
Fax 610-593-2002
Please write for a free catalog.
This book may be purchased from the publisher.
Please include $2.95 for shipping.
Try your bookstore first.

We are interested in hearing from authors with book ideas on related subjects.

Designed by Joy Shih Ng
Printed in China
ISBN: 0-7643-0158-6

Table of Contents

Acknowledgments

A text like this is never produced alone. It took the cooperation and hard work of many individuals to complete this book. I wish to thank them all. A special thanks to Rich Brenneman who did a wonderful job assisting with the photography and to Doug Congdon-Martin, who created the opportunity to accomplish this study. Doug's encouragement is always appreciated.

I would also like to thank Bob Page, Gary S. Corns, and Jaime L. Robinson for their assistance throughout this project. Bob Page is the president of Replacements Ltd. and graciously allowed us access to his stock of Franciscan ware. Gary S. Corns saw to it that the materials, pricing information, and personnel we needed were available. Jaime L. Robinson saw that all of the Franciscan wares photographed were brought to us and properly identified. Without all of their efforts, this book could not have been completed.

Replacements, Ltd. Company History

In the 1970s, Bob Page, founder and president of Replacements, Ltd., began collecting china and crystal as a weekend hobby from his job as an auditor for the state of North Carolina.

As friends learned of his pastime, they asked him to be on the lookout for particular patterns to replace pieces that they had lost or broken. Before too long, Bob found himself devoting more and more time to his hobby, often staying up until the early hours of the morning to fill orders. Bob stored the china and crystal in his attic, while his bedroom served as his office.

In 1981, he left his auditing career and began Replacements, Ltd. with one part-time assistant. Tremendous response from small ads placed in national shelter magazines such as *Southern Living* and *Better Homes and Gardens* dramatically ex-

panded his list of potential customers. Customer requests were recorded on 3 x 5 index cards, which eventually grew to an information base containing pattern and piece requests, as well as prices quoted and purchases, for over 1,000,000 customers nationwide. Sales for 1981 reached $150,000 and by 1984, they were close to $4 million. In 1995, sales exceeded $37 million.

Replacements, Ltd. began conversion to computer in 1984, and now, with an inventory of over 3.2 million pieces in over 62,000 patterns, is fully automated.

Each week, thousands of pieces of china, crystal and flatware are shipped to Replacements, Ltd. from a network of over 1,000 dealers. Each piece is carefully inspected and then assigned a location on one of more than 45,000 shelves in the warehouse. The new inventory is then logged in the computer system and specially developed programs match the pieces with customer requests. Combination customer notification/return order forms are then printed and mailed to customers notifying them of pieces now available in their pattern. Over 250,000 of these notices are sent out weekly.

Customers place orders by mail, fax or phone. The orders are distributed to the warehouse to be pulled, inspected, and then shipped to the customer.

Maintaining an impeccable reputation and providing the best possible service to Replacements' customers has always been the basis of Bob Page's philosophy of business. It has provided a strong foundation from which Replacements, Ltd. has grown and given direction for continuing growth.

The Franciscan ceramics shown in this text are all from Replacements, Ltd. Replacements, Ltd. both buys and sells Franciscan ware. Replacements, Ltd. may be reached at 1-800-REPLACE. You may write or visit them at 1089 Knox Road, P.O. Box 26029, Greensboro, NC 27420.

Foreword

The Gladding McBean (GMB) Franciscan Company had an interesting start in the 1930s, producing high quality casual china lines that were colorful, durable, and guaranteed to be craze resistant. At first there were a limited number of patterns made, nevertheless several colors were produced. As time went on, the array of patterns and shapes manufactured grew immensely, eventually leading to Franciscan Fine China and Masterpiece China.

One of America's most favorite casual china patterns is Desert Rose; in 1964, the sixty-millionth piece of it had been produced. Whether being made in the United States or England, it has been in continuous production since 1941. First ladies such as Jacqueline Kennedy had even chosen Franciscan Masterpiece China.

Some of America's favorite television families of the 1950s-1960s also had Franciscan. The "I Love Lucy Show" and "The Donna Reed Show" both featured the hand painted Ivy pattern. Other television shows such as "I Dream of Jeannie" had Apple, "The George Burns and Gracie Allen Show" had Tiempo, and "The Farmer's Daughter" featured the Malibu pattern.

In June of 1978, Franciscan Masterpiece China was discontinued altogether. Later in July of 1984, fate was closing in on the company, and Franciscan casual china would cease production in the United States.

The primary focus of this book is the American-made Franciscan, although we have tried to encompass the full spectrum of their other chinaware including the lines that were produced in Japan such as Cosmopolitan China, Whitestone Ware, Franciscan Porcelain, and Fine Bone China and their English Ironstone patterns made in England.

Growing up in the Northwest, I visited such local Seattle department stores as Frederick & Nelson and Peoples, which featured Franciscan. I always knew that it was a product of high quality and was proud our family used it.

In the early 1980s, my awareness of Franciscan was heightened and I realized the value and importance of this hand-crafted, American-made product. At that time I began to shop estate sales, flea markets, and swap meets in search of discontinued Franciscan. Whether it be Royal Renaissance Masterpiece China or Starburst casual china, it was always fun researching and discovering previously unknown shapes and patterns.

My interest in researching American-made china, crystal, and flatware brought me recently to Replacements in Greensboro, North Carolina, where I have a career as a curator and a staff member of the research department.

Today, fifteen years after Bob left his auditing career to begin Replacements, Ltd., the company's massive inventory of discontinued and active china, crystal, and flatware includes over 440 Franciscan china and casual china patterns. Replacements locates hard-to-find pieces and employs 370 people.

I want to thank the following whose combined efforts are largely responsible for the success of the Franciscan photography project: Dale Frederiksen and Gary Corns, and many other talented staff members of Replacements, Ltd. Most of all Bob Page, founder and president of Replacements for making this opportunity come true.

The tradition of Franciscan china still continues to grace American tables today as it did in yesteryear, by those who either bought it new or have inherited sets. Good luck in your venture of filling out your pattern or replacing missing pieces. And I hope you get as much enjoyment in your search and use of it as I did in helping put together this publication.

Jaime Robinson, Curator
Replacements, Ltd.

Introduction

Gladding, McBean and Company introduced "Franciscan Pottery" to the American public in 1934. For the next fifty years popular, colorful ceramic tablewares of modern design called "Franciscan" were produced in Glendale, California. Over the years, production was prodigious — close to 150 earthenware patterns and over 185 china patterns were produced. These took on the forms of dining services, kitchenware, and decorative pieces. The most popular patterns in the Franciscan line were embossed, hand-painted designs created in the 1940s, known as Apple, Desert Rose, and Ivy. These patterns continue to be favorites among collectors today.[1]

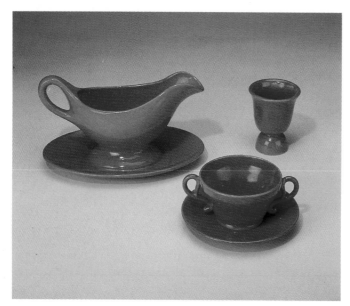

The brilliant red **El Patio** pattern with a glossy glaze, Gladding, McBean's first Franciscan pattern dining service. El Patio, gravy boat with attached underplate, egg cup (3 1/2" h.), and cream soup and saucer set.

The **Apple** pattern adorns these earthenware mixing bowls (6" 7 1/2", & 9" d.), 1940.

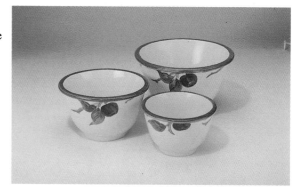

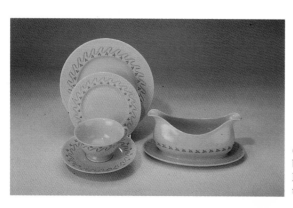

Crinoline pattern china salad plate (8 3/8" d.), bread and butter plate (6 1/4" d.), cup (2 1/8" h.) and saucer, and gravy boat with attached underplate.

6

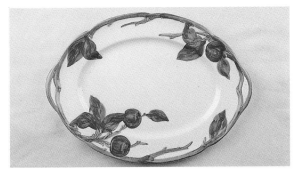

Apple platter (14 1/8" d.), made in America.

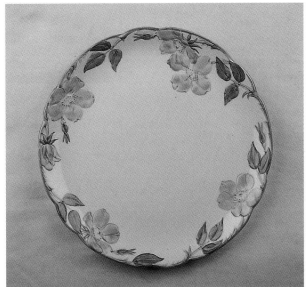

Desert Rose round chop plate (11 1/2" d.).

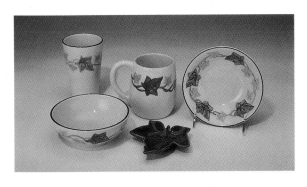

Ivy tumbler (5"h., upper left), fruit bowl (5 3/8" d., lower left), mug (4 1/2" h.), ivy leaf shaped ashtray (4 1/2" w., bottom center), and saucer.

The name "Franciscan" was a tribute to the Franciscan Friars who had established missions in California in centuries past. In 1936 the name was changed from "Franciscan *Pottery*" to "Franciscan *Ware*." The name "ware" was believed to convey a greater sense of quality. In 1962, Gladding, McBean and Company merged with the Lock Joint Pipe Company and was renamed Interpace; in 1979 Interpace sold the California plant to Wedgwood Limited of England which promptly renamed the facility Franciscan Ceramics Inc. Through it all, this popular ceramics line retained the Franciscan name.[2]

Franciscan *Pottery* was renamed Franciscan *Ware* in 1936 to convey a greater sense of quality. A large Franciscan Ware plaque featuring the monestary used on Gladding, McBean and Company Franciscan manufacturers' marks from 1941-1947. This plaque was printed in both black and brown; the ceramic plaques measure 5" wide x 3 1/4" high.

Chapter 1. History

In 1875, Charles Gladding, Peter McBean, and George Chambers discovered clay deposits in Placer County, California, and promptly established the firm of Gladding, McBean and Company in the town of Lincoln to manufacture sewer pipe for industries west of the Mississippi.[1] In 1884, the company began producing architectural terra cotta, followed by tile and other building materials. In 1923, Gladding McBean bought Tropico Potteries, Inc. in Glendale, California, which had been a manufacturer of tile and faience since 1904. This site, located at 2901 Los Feliz Boulevard in Glendale, would become the manufacturing plant for Franciscan pottery in the 1930s.[2]

In 1928, Dr. Andrew Malinovsky improved on a formula Gladding McBean had recently purchased from its inventor, T.C. Prouty. The improved formula used talc as a primary component in the creation of a new earthenware body for ceramics and other applications. The resulting talc earthenware body Malinovsky produced was patented by Gladding, McBean and Company as "Malinite."[3]

In 1932, experiments were performed at the Lincoln plant to create dining services and art wares with the new malinite body material, wares which would be decorated with solid-color glazes. Their experimentation followed a trend among California potteries, firms which had been producing building materials were beginning to make tablewares for the growing California market. Gladding, McBean and Company and its competitor Vernon Kilns both grew rapidly at this time.[4]

Gladding McBean expanded again in 1933, purchasing the American Encaustic Tiling Company and thereby gaining the use of American Encaustic's two "Prouty" tunnel kilns, capable of firing ceramics at relatively low temperatures. These kilns, along with the addition of a flux to the glaze, enabled Gladding McBean to fire their malinite body and glaze together in a single step at lower kiln temperatures than used previously. A flux is an additional oxide which mixes with the silica oxide of glaze and lowers its melting temperature. This single firing process fused the glaze with the malinite body, dramatically reducing the chances of the glaze crazing as it aged. The company was now poised to successfully compete in the tableware market.[5]

Fredrick J. Grant, a chemical engineer and former president of Weller Pottery in Zanesville, Ohio, was hired in 1934 to manage the new pottery department established at the Glendale plant. His challenge was to create complete lines of tablewares, kitchenwares and art wares using the new malinite body and single fire process. To this end, Grant turned to his wife Mary to develop the style for the new Franciscan Pottery line. An art director herself, Mary K. Grant produced many enduring patterns over the years. She was not, however, placed on the company payroll until 1938.[6]

Mary K. Grant designed the first Franciscan dinnerware pattern, El Patio, produced in August of 1934. El Patio place settings were available in six

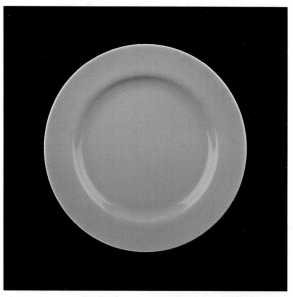

El Patio, the first Franciscan dinnerware pattern. This example has a solid aqua color pattern and a glossy glaze. It is a salad plate.

8

solid colors and were accompanied by casserole dishes and mixing bowls.[7]

Apparently the director for the Metropolitan Museum of Art in New York was impressed with Gladding McBean's early dinnerware, as he invited the firm to participate in the upcoming Exhibition of Modern Industrial Contemporary Art. Two special art pieces christened with the pattern name Metropolitan were designed by Morris Sanders for the show: a vase and a large pottery bowl. These were on display in November 1934 and were the only pieces displayed by an American firm. Both pieces were glazed in two colors, a different color for the inside and the outside of each piece.[8]

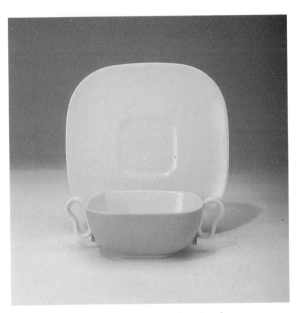

Metropolitan, Mauve, cream soup bowl and saucer.

When the first company catalog was released in April of 1935, Franciscan Pottery patterns included El Patio, El Patio Nuevo, and Coronado. By December, 283 different shapes were in production.[9]

In 1936, Gladding McBean changed the name Franciscan Pottery to Franciscan Ware. In 1937, they purchased the Catalina Clay Products Division of the Santa Catalina Island Company, which had been producing Catalina dinnerware and art ware. Gladding McBean would continue to produce a Catalina pottery line until c. 1942.[10]

Gladding McBean had fifteen patterns in their Franciscan dinnerware line and nine in art ware by 1939. During 1939 they also developed the embossed and hand-painted underglazed patterns

which would give them their most popular patterns during the 1940s. In 1940, the company introduced their first embossed and painted pattern, Apple. Around 1941 they added Desert Rose to

Apple dinner plate. The Apple embossed, hand-painted pattern was introduced in 1940.

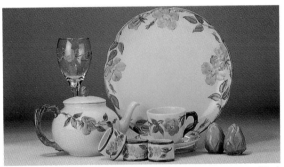

The **Desert Rose** pattern was added to the Franciscan line in c. 1941.

this line and in 1948, Ivy was produced, rounding out the most popular trio of patterns in the Franciscan line. In between, in 1942, Gladding McBean created Wild Flower, which proved to be their most labor intensive embossed and painted pattern.

During the early 1940s, Gladding McBean also began to produce high quality china dining services under the names Masterpiece China and Franciscan China. In 1947, the name Franciscan China was changed to Franciscan Fine China.[11]

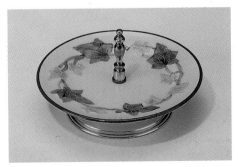

Ivy was first produced in 1948. Ivy tidbit tray with a brass center spindle and brass foot.

9

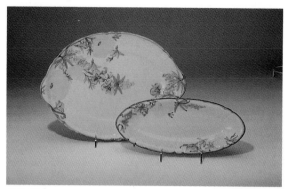

Wildflower, Gladding McBean's most labor intensive embossed, hand-painted pattern. Wildflower platter (14" l.) and relish dish, pickle (12" l.).

Gladding, McBean and Company merged with the Lock Joint Pipe Company in September of 1962, changing the company name to the Interpace Corporation. New Franciscan patterns produced by Interpace, in addition to the continuing earlier patterns, included Meadow Rose, October, Gourmet, and Forget-Me-Not.

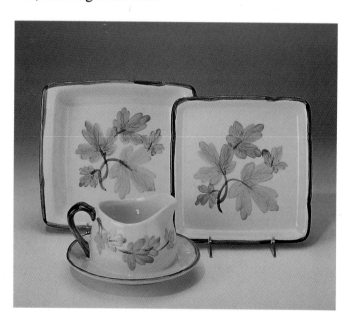

October square baker's dish (9 5/8" d., left), square tray (8 1/4" d., right), and gravy boat.

During the 1960s, Interpace also sought to produce a number of Franciscan patterns at a lower cost. Interpace cut costs by having patterns produced in Japan on both whitestone ware and bone china. The Japanese-made dishes are not commonly found today, especially the patterns on bone china, as these wares were not of good quality and were easily broken. Patterns from Japan found on whitestone ware include Pink-a-dilly and Swing Time. Japanese patterns on bone

china include Bridgeton, Equus, and Windemere. Japanese Franciscan patterns continued to be produced into the 1980s.[12]

Interpace added to its holdings in c. 1971 by purchasing Myott-Meakin, a pottery in England's

Swing Time was produced in Japan on Whitestone Ware. Swing Time, five piece place setting. Dinner plate (10 1/4" d.); salad plate (8 1/4" d.); bread and butter plate (6 1/8" d.); cup (2 3/4" h.) and saucer.

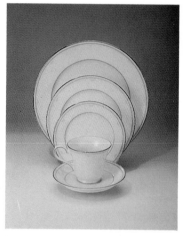

The Japanese **Bridgeton** pattern on bone china. Bridgeton five piece place setting. Dinner plate (10 3/4" d.), salad plate (8 1/8" d.), bread and butter plate (6 1/2" d.), cup (3" h.) and saucer.

Staffordshire potting district. Through the Myott-Meakin pottery, adaptations of Franciscan patterns were produced for the British market and for Europe. Wedgwood Limited purchased the 45 acre Glendale plant from Interpace in 1979 and renamed the company Franciscan Ceramics Inc. New patterns produced from 1980 to 1983 included Rosette, Bouquet, Cafe Royal, Strawberry Time, and Twilight Rose. In 1984, plagued by economic recession, Wedgwood Limited closed down the Glendale plant, moving operations back to England. Franciscan Ceramics Inc. became part of the larger British corporate entity known as the Wedgwood

Group. The potting firm Johnson Brothers, another Wedgwood Group member, currently owns Franciscan and produces the Apple and Desert Rose patterns. They also have added new patterns such as Orchard Glade to their Franciscan line.[13]

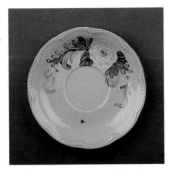

Bouquet saucer.

Strawberry Time saucer, 1983

Cafe Royal trays.

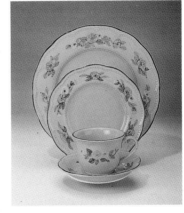

Rosette dinner plate (10 3/4" d.), salad plate (8" d.), cup (2 3/4" h.) and saucer.

Company History Summary

1875 Gladding, McBean, and Chambers openGladding McBean & Company in Lincoln, California.

1923 Gladding, McBean and Company purchase Tropico Potteries, Inc. of Glendale, California. All American Franciscan would be produced at this Glendale plant beginning in 1934.

1928 Gladding McBean develops and patents "Malinite" talc earthenware.

1932 Gladding McBean experiments with dining services and art ware at the Lincoln plant.

1933 Gladding McBean purchases American Encaustic Tiling Company.

1934 Gladding McBean produces the El Patio pattern dining service at the Glendale plant, the first Franciscan Pottery pattern.

1936 Franciscan Pottery is renamed Franciscan Ware.

1940 Gladding McBean produces their first embossed, hand-painted pattern, Apple.

1960s First Gladding McBean and then Interpace (see 1962) have inexpensive ceramics lines produced in Japan. This practice continues into the 1980s.

1962 Gladding McBean merges with the Lock Joint Pipe Company. The joint company is renamed Interpace.

1971 In c. 1971 Interpace purchases the Myott-Meakin pottery in Staffordshire England.

1979 Wedgwood Limited purchases the Glendale plant from Interpace.

1979 Wedgwood Limited renames the Glendale plant Franciscan Ceramics Inc.

1984 Franciscan Ceramics Inc. closes the Glendale plant and moves all Franciscan production to England.

Chapter 2. Franciscan Ware. Materials and Patterns

Body Materials

Over the years, Franciscan ware was produced in three distinct types of body material. The first produced was the "malinite," a cream colored earthenware. Next came the chinas, Masterpiece in 1940 and Franciscan China in 1942. These were quality translucent vitrified china wares. Finally, Franciscan ware was also produced in a whitestone ware, a white earthenware first used by Gladding McBean in 1959. Many have considered the famous Desert Rose pattern adorning malinite dinnerware to be the most popular dining service produced in America.[1]

Advertising Signs

When new Franciscan earthenware and china lines were displayed, they were accompanied by advertising signs such as these.

A large Franciscan Ware plaque featuring the monastery used on Gladding, McBean and Company Franciscan manufacturers' marks from 1941-1947. This plaque was printed in both black and brown, the ceramic plaques measure 5" wide x 3 1/4" high.

Franciscan Masterpiece China, an unusual black ceramic sign measuring 5" x 3". Masterpiece China was a fine, thin china first introduced in the early 1940s.

This Franciscan sign advertising the Palomar pattern was in use during the late 1940s - early 1950s. Burgundy lettering adorns this 4 3/4" wide x 1 1/8" high sign.

The Renaissance pattern entered the market in 1949 with Renaissance Gray. Additional colors were added over the years. This sign measures 4 3/8" wide x 1" high.

Franciscan China was renamed Franciscan Fine China in 1947. Franciscan Fine China ceramic advertising sign.

The Chelan pattern was introduced in 1950. Ceramic sign measuring 4 3/8" wide x 1" high.

Franciscan fine China ceramic sign, in use from the mid-to-late 1950s, measuring 4" wide x 3 1/8" high.

Black lucite sign with white lettering used during the late 1960s and early 1970s. 4 1/4" wide x 1 1/4" high.

Interpace adopted the phrase "California Craftsmen since 1875" in 1974 to encourage the idea that their wares were hand-crafted. 5" wide x 1 1/2" high.

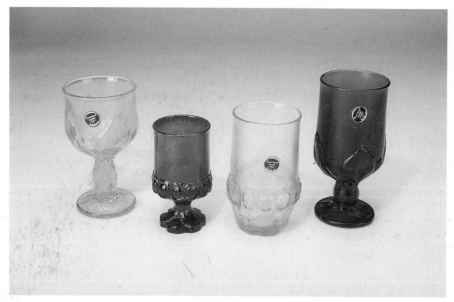

Lucite advertising block.

Franciscan Crystal was produced during the 1970s to accompany their china dining services. This crystal came in a variety of colors and shapes. Left to right: cornsilk (color), cabaret (pattern) goblet; ruby, madeira goblet; pink, madeira tumbler; and blue, cabaret iced tea glass.

Franciscan Shapes and Terms

In the 1930s, California potteries, including Gladding McBean, began producing bright colored patterns on ceramic bodies composed of inexpensive local talc in place of clays. Gladding McBean's early efforts centered on smooth and simple shapes decorated in bright, single-color patterns. America's Great Depression, from 1929 into the early 1940s, inspired in-house pottery designers to seek the most economic production strategies for their wares. Gone were the earlier dinner sets with intricately shaped vessels and eight piece place settings. Streamlined shapes and five pieces place settings became common.[2]

In the 1950s, Gladding McBean's ceramic shapes changed, taking inspiration from the works

Typical 1950s shape. **Oasis** ashtray (7 3/8" d.).

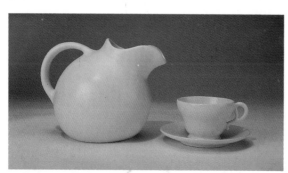

Gladding McBean's early efforts centered on smooth and simple shapes. **El Patio**, white, matte glaze, pitcher (5" h.), cup (2 1/4" h.) and saucer.

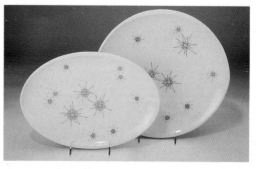

Another example of Gladding McBean's 1950s shape change. **Starburst** oval serving platter (15 1/8 d.), round serving platter. (13 1/8" d.)

14

of artists such as Salvador Dalí. Professor Leslie Piña described these shapes as resembling "...earlier modern forms with the bones removed or partially deflated..." Gladding McBean (or Interpace after 1962) continued to produce their wares successfully into the late 1960s. However, by the early 1970s, demand for their tablewares was dropping. Franciscan lines were updated with patterns such as Calypso and Sun Song. Sun Song was produced on a newly developed line of body shapes identified as Kaleidoscope.

The shapes in the Kaleidoscope line were influenced by a renewed interest in 1930s design.[3]

As popular and adaptable as the Franciscan lines were over the decades, foreign competition and an economic recession proved insurmountable odds against which new designs and patterns could not be produced. Wedgwood Limited closed the doors of Franciscan Ceramics Inc. in 1984.[4]

An example of the Kaleidoscope body shape. **Sun Song** dinner plate.

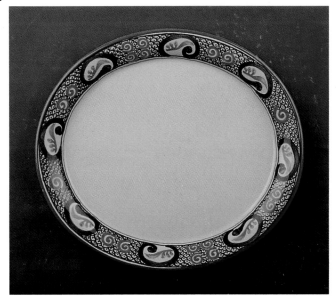

Calypso platter (14" l.).

Plates and Bowls

Franciscan plates and bowls come in two general forms, rim shape and coupe shape. Rim shape plates or bowls have a traditional lip. Depending on the design, that lip may be wide or narrow and embossed or plain. Coupe shape plates and soup bowls have no rim whatsoever. This is a more contemporary shape; for plates the coupe shape tends to be flat across the diameter and rolls up slightly at the edge.[5]

Generally speaking, Franciscan plates are predominantly circular in shape (although some square plate shapes were produced), measure from 7" to 15" in diameter, and have low sides. Dinner plates average 10" in diameter. Plates with tall sides are generally intended for baking purposes.[6]

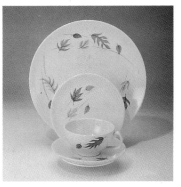

An example of coupe shape plates. **Autumn** dinner plate (10 1/2" d.); bread and butter plate (6 1/2" d.); cup (2 1/8" h.) and saucer.

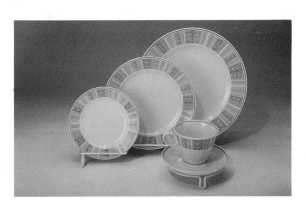

An example of rim shape plates. **Antique** five piece place setting. Dinner plate (10 3/8" d.); salad plate (8 1/4" d.); bread and butter plate (6 1/4" d.); cup (2 3/4" h.) and saucer.

Platters

"Platter" is an American term for the large, generally oval-shaped, dish used to serve meat. Platters may also be rectangular or round in shape. A platter can measure from as little as 10" in length on up to 18" in length or more. Chop plates are circular, platter-like forms measuring 11" or more in diameter.[7]

Encanto Rose platter.

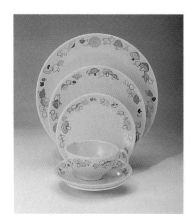

Five Piece Place Setting

This includes a cup and saucer, dinner plate, salad plate, and a bread and butter plate. Many of the Franciscan patterns displayed in this book are shown in their five piece place settings.

Woodlore five piece place setting. Dinner plate (10 5/8" d.); salad plate (8 1/4" d.); bread and butter plate (6 1/2" d.); cup (2 1/4" h.) and saucer.

Salad Plates

A number of Franciscan dining services include roughly crescent moon shaped plates that those familiar with Victorian dining services would classify as bone dishes. These plates are side salads. Other Franciscan patterns have more conventional round shaped salad plates which measure roughly 8" in diameter. Some patterns have both.

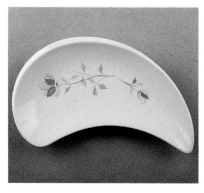

Duet side salad (9" x 4 1/2").

Cream Soup and Saucer Sets

A cream soup bowl has two handles, one on either side of the bowl. The set comes with a saucer on which the bowl rests.

Metropolitan cream soup bowl and saucer. Aqua exterior color with an interior white liner.

Gravy Boats

Franciscan gravy boats are worth a brief mention as they come in two different forms. The first has a spout and handle for pouring the gravy. The second has what appears to be two spouts and no handle. These "spouts" are actually rests for the ladles used to spoon out the gravy. Either form may have separate or attached underplates.

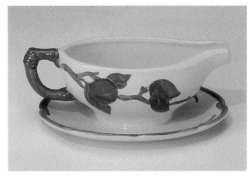

Apple gravy boat with attached underplate.

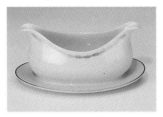

Arcadia Gold gravy boat with attached underplate.

Franciscan Tea and Coffee Pots

Franciscan teapots tend to be short and stout in form. Coffee pots are tall and thin by comparison.

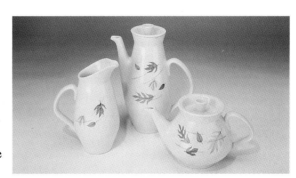

Autumn pitcher, coffee pot, and teapot.

Demitasse Cup

A very small cup, with a saucer, used for serving coffee after a meal. This is primarily an American term.

Coronado, Aqua Glossy glaze, demitasse cup and saucer, sugar bowl, salt and pepper shaker.

Kitchenware

All of the items of Franciscan ware used in the kitchen fall into this category. These include canisters, mixing bowl sets, range sets, refrigerator water jugs and leftovers containers, and ovenware. Ovenware refers to dishes which are designed to withstand an oven's heat and which play the additional role of serving the food that has been cooked in them at the table.[8]

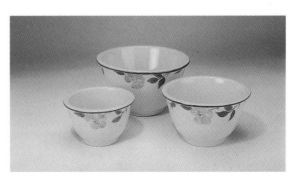

Desert Rose three piece mixing bowls set.

17

Art Ware

Most of the odd little knick-knacks and niceties which will not fit into either dining service or kitchenware categories fall under this heading. Art ware includes ash trays, bells, candle holders, cigarette holders, clocks, ginger jars, lidded boxes, piggy banks, thimbles, tiles, and trays.[9]

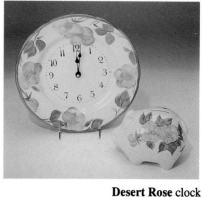

Desert Rose clock and bank, made in England.

Poppy ashtray.

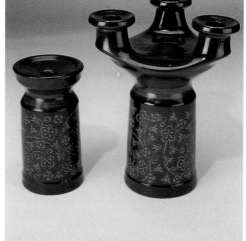

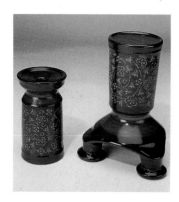

Madeira candle holders. The right hand holder is reversible and will hold one or three candles.

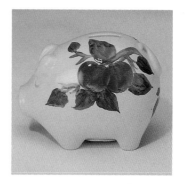

Apple piggy bank, made in America.

Specials

In addition to art ware, there were also "specials," pieces produced to be given away. Trays and jam jars were the most popular specials, although any new Franciscan design which did not conform to one of the standard dining, kitchen, or art ware categories was listed as a special item. There were quite a few of these over the years, roughly 200 different types of Franciscan specials are known to exist.[10]

A final note on forms, the vessels with lids are the most difficult to find complete. The difficulty comes in finding the lids themselves, whether they are lids from tea and coffee pots, covered vegetable dishes, sugar bowls, or cookie jars. Lids were the most frequently broken or misplaced items of Franciscan ware.

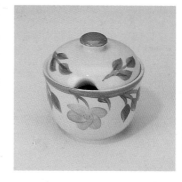

Desert Rose jam jar (3 1/2" h.). The hole in the lid accommodates a small spoon.

Patterns

Just as Franciscan body materials came in three general categories over the years, Franciscan patterns fall into three general types as well. They are 1) solid-color patterns, 2) embossed, hand-painted patterns, and 3) decaled patterns. Some of these patterns also came in either a glossy or a matte glaze finish. The early patterns were derived from Mexican and early American designs.[11]

The following are examples of each of the pattern types.

Solid-Color Patterns

Solid-color patterns generally come in a single color although two-tone patterns were also produced. The very first Franciscan dining service was manufactured in a solid-color pattern.

El Patio was the first Franciscan dining service line produced. It was made in 20 different solid-colors and over 103 shapes. Cup and bowl handles have

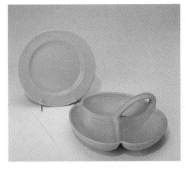

El Patio, coral, matte glaze, salad plate (8 1/2" d.) and three part handled relish dish (9 1/2" d.).

a distinctive shape, which Deleen Enge describes as "pretzel shaped." This pattern was in production from 1934 to 1953. A short-lived variation on this pattern, **El Patio Nuevo**, was manufactured in a two-tone pattern from 1935 to 1936. The interiors and exteriors were given different solid-colors.[12]

Another well known solid-color pattern produced in the 1930s (c. 1936) was **Coronado**. Also called Swirl by some for the spiraling shape molded into the pottery, Coronado was decorated in both satin matte and glossy glazes.[13]

In 1940, Morris Sanders designed the **Metropolitan** pattern for the aforementioned New York industrial design exhibition at the Metropolitan Museum of Art. Originally, Metropolitan was produced in Ivory, Ivory and Coral, Ivory and Grey, and Ivory and Turquoise satin finish colors. In color combinations, Ivory was used for lids and handles, and as a liner. Plum and Chocolate Brown patterns were also produced, each with Ivory liners. All of the vessel forms in Metropolitan were either square or rectangular.[14]

Metropolitan, Grey, dinner plate. All of the pieces in Metropolitan are either square or rectangular in shape.

Finally, the Metropolitan shape was used again from 1949 to 1954 with the **Tiempo** pattern. Tiempo featured solid glossy glaze colors in Copper, Hot Chocolate, Leaf, Mustard, Pebble, Pink, Sprout, Stone, and White.[15]

Coronado, Aqua matte glaze, dinner plate.

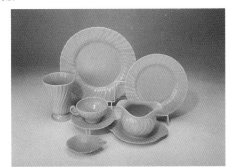

Coronado, Aqua matte glaze, dinner plate (10 1/2" d.), salad plate (8 1/8" d.), vase (5 1/2" h. on left), cup (2 1/8" h.) and saucer, gravy boat with attached underplate (right), and ashtray (front center).

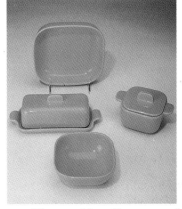

Tiempo, Lime Green, cereal bowl (top), covered butter dish (left), sugar bowl (right), and fruit bowl (4 1/2" d., bottom).

These patterns had decorative shapes embossed into the ceramics. These raised shapes were then hand-painted to complete the decoration prior to glazing. Some of these are the most beautiful and sought-after Franciscan patterns, including Apple, Desert Rose, and Ivy. Ivy also has the distinction of having adorned the fictional television homes of Donna Reed and Lucy Ricardo. Apple and Desert Rose continue to be produced in England.

Apple was the first embossed, hand-painted pattern. It was introduced on January 1, 1940 and continued to be produced at the Glendale plant until its closing in 1984. Mary Jane Winans created the Apple pattern, with its bright red fruit, brown branches and glossy green leaves; Mary Grant produced the vessel shapes. All of the lids have Apple finials.[16]

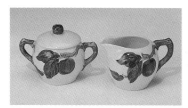

Apple covered sugar and creamer.

By early 1942, Apple was followed by **Desert Rose**, a pattern sporting pink wild roses, light brown thorny branches, and green leaves. Mary Jane Winans designed the Desert Rose pattern and adapted existing vessel shapes for this line. The finials on the lids are in the shapes of rose buds.[17]

On three separate occasions, children's sets were offered in the Desert Rose pattern. One set included a 7 ounce mug and a divided, three part plate measuring 9" in diameter. Another contained a 10 ounce mug and a divided, three part

plate. The third set was offered with a coupe shaped dessert plate, a 7 ounce mug, and a porringer.[18]

Three variations of the Desert Rose pattern were produced between 1977 and 1983. The first was **Meadow Rose**, introduced in 1977. Meadow Rose colors were changed to create yellow roses, however, the vessel forms remained the same. Next came **Cafe Royal** in 1981, altering the colors and glazes yet again into browns and whites. Finally, in 1983, **Twilight Rose** was introduced, most notable for the use of a blue trim which compliments the pale pink flowers with their yellowish centers. The number of shapes produced for this pattern was limited. Twilight Rose was both the final Desert Rose variation and the final pattern produced at the Glendale plant.[19]

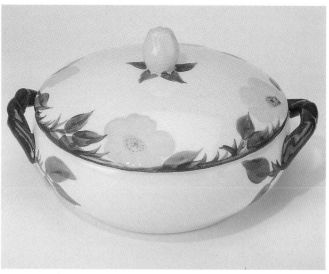

Meadow Rose round vegetable bowl.

Cafe Royal cookie jar (left) and round covered vegetable dish (9 1/8" d., on right - this vegetable dish was also produced in a round 8" d. size).

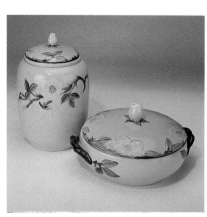

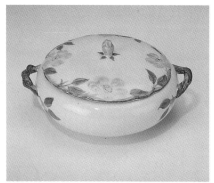

Twilight Rose round covered vegetable dish, the final variation of the Desert Rose pattern.

Desert Rose covered vegetable dish (9 1/2" d. x 4 3/4" h.).

Ivy was introduced in 1948, rounding out the trio of most popular Franciscan patterns, and remained in production until 1983. This pattern was also designed by Mary Jane Winans, who seemed to have a flair for winning patterns. Ivy was originally offered with 27 shapes. Additional vessel shapes were added in the 1950s, including comports, a covered butter dish, a 12 ounce mug, a relish dish with three sections, a side salad, sherbet dishes, and a TV tray.[20]

For the Apple, Desert Rose, and Ivy patterns, Imperial Glass produced matching glassware. Matching tea kettles were also created. These additional pieces are well worth looking for.[21]

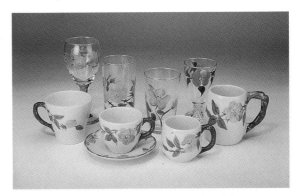

For the Apple, Desert Rose, and Ivy patterns, Imperial Glass produced matching glassware. **Desert Rose** cups, mugs, glass tumblers and glass stemware. Front, left to right: 10 ounce mug (3" d. x 4 1/4" h.), cup (2 1/4" h.) and saucer (5 3/4" d.), 7 ounce mug (3" d. x 2 3/4" h.), and 12 ounce mug (3 1/4" d. x 4 1/4" h.). Back, left to right: tall stemware glass with hand painted pattern (7" h.), tall tumbler with hand painted pattern (6" h.), short tumbler (5 1/4" h.), and short stemware glass (5 1/2" h.), both with transfer printed patterns.

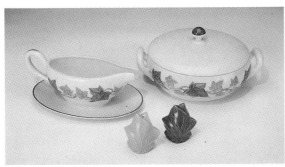

Ivy gravy boat with attached underplate (9" l. x 2 1/2" w. x 5" h.), covered casserole (7 3/8" d.), and salt and pepper shakers (2 3/4" h.), each shaker in the shape of an ivy leaf.

Decaled Patterns

These are underglazed transfer printed patterns produced from the late 1930s right on through to the 1980s. The most popular of these decaled patterns is vintage 1950s design, the **Starburst** pattern. Introduced in 1954, Starburst features large and small blue and yellow dots through which black lines radiate. The vessel shape was named Eclipse and was designed by George James.[22]

The Eclipse shape was also used on the decaled **Duet** and **Oasis** patterns. The Duet pattern, released in 1956, consists of two crossed flowers with gray stems and leaves, topped with pink and red flower petals. Oasis, introduced in 1955, is a geometric design composed of black lines, blue and gray rectangles, and small blue starbursts.[23]

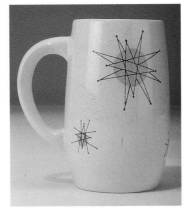

The most popular of the decaled patterns is vintage 1950s design, the Starburst pattern. **Starburst** mug, 1954-1956.

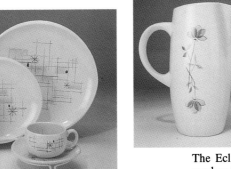

Oasis five piece place setting. Dinner plate (10 7/8" d.), salad plate (8" d.), bread and butter plate (6 1/2" d.), and cup (2 3/8" d) and saucer.

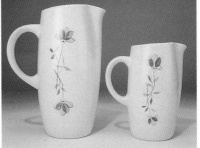

The Eclipse shape was also used on the decaled Duet and Oasis patterns. **Duet** pitchers.

Chapter 3. Manufacturer's Marks

Manufacturers' marks are one of the best and easiest ways of identifying Franciscan wares. These useful marks generally contain a firm's name or initials, symbol, and location — or some combination of these. Pattern and/or shape names frequently accompany manufacturers' marks. Unfortunately, while Gladding, McBean and Company, Interpace, and Wedgwood created a prodigious number of marks, they did not consistently mark all of their Franciscan wares over the years.

However, what follows is a series of guidelines for identifying marks, and their components, as you encounter them while collecting these fascinating and colorful wares, along with a survey of some of the many marks which have been produced for Franciscan over the years. No single source yet, including this one, has recorded all of the marks used over the fifty years of American Franciscan production. That challenge remains for some dedicated future scholar.

General Guidelines for Marks

Manufacturers' marks are found on the bottoms of plates and the bases of hollow wares. The component most often found in a manufacturer's mark is either the name or the initials of the company. This is not always found, however. At times only the pattern or shape name was used.

The mark "Made in U.S.A." has been required by Congress to be placed on all export items since 1898. "Made For" is an entirely different matter. This mark is used when a line has been produced specifically for a department store or a distributor. That store or distributor's name is generally included and may be a useful guide to dating the marked ware if the date of operation for that source is known.[1]

Pattern names appear on some, but by no means all, Franciscan wares. When they are not present, the color photo guide to many of the Franciscan patterns which follows is particularly useful. Shape names are also included on occasion and refer to the name given to the ceramic body shape of a particular line such as Eclipse. The Eclipse shape was used with the Starburst, Duet, and Oasis patterns. At times, shape names are indicated by nothing

more than a letter code or a special stamp below the manufacturer's name.

Solid-color patterns in bright hues were very popular in the late 1920s and the 1930s, as evidenced by early Franciscan patterns. Particular favorites with many potters were pink, ivory, yellow, green, and blue. Pink, ivory, and yellow were also frequently used as background colors for decaled patterns. There were times when these colors were given their own names or incorporated into the pattern or shape name. Golden, dawn, rose, blush, and creme frequently find their way into the names, such as Franciscan patterns Gold Leaves and Golden Weave.[2]

The term "Oven Safe" first appears on Franciscan marks in 1953. Microwaves were first available to the public in limited quantities in the 1950s; however, they were not used by the general public in any numbers until the 1970s. Franciscan marks bearing the "Microwave Safe" assurance appear around 1974.

Now that we have covered some general ground rules about marks, it is time to move on to the specifics about Franciscan marks.

Gladding, McBean and Company

The first mark used by Gladding, McBean and Company when they began their foray into dining services in 1934 incorporated the company initials GMcB inside of an oval. This mark came in two sizes and appeared with or without the phrase "Made in U.S.A."[3]

The first Franciscan mark used was a large capital F placed within a single or double lined box. This replaced the GMcB oval mark in September of 1938 and was in use until February 1939.[4]

The F was replaced initially by the words Franciscan Pottery. Franciscan Pottery was quickly replaced by Franciscan Ware, a phrase Gladding McBean felt was more elegant. These two were in use from 1938-1939.[5]

Circular Franciscan Ware marks with the phrase Made In California U.S.A. were in use from February 1939 through 1947. In July 1940 Hand Decorated was added to the mark, Hand appearing above the circle and Decorated appearing below. From 1947 to 1949 numbers were added beneath these circular marks. These numbers identified specific workers.[6]

Circular Franciscan Ware mark in use from February 1939 to 1947 in various forms. Worker identification numbers were added beneath this mark from 1947 to 1949.

 This arched Franciscan mark was in use from 1949 to February 1953.

Oval Franciscan China mark with monastery was in use from 1947-1953. The Spruce pattern was introduced in 1952.

 This circular mark bearing the Malinite body name was used from 1954 to 1956. This example appeared on the back of a Coronado pattern dinner plate.

Two circular marks containing the phrase "Color-Seal" and dating from February 1954 to July 1958. "Oven-Safe" first appears on a circular mark similar to this with "Hand Decorated" in the center rather than "Color-Seal" and dated from February 1953 to July 1958.

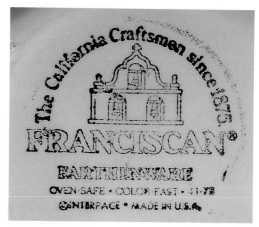

Franciscan Fine China mark appearing on the bottom of a Contours art ware ashtray, dating from July 1955 to December 1956.

In 1974 Interpace added "The California Craftsmen since 1875" to their mark.

Interpace

Rectangular Interpace mark used first in December 1964.

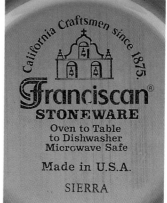

Franciscan STONEWARE
Oven to Table to Dishwasher
Microwave Safe
Made in U.S.A.
SIERRA

This style of rectangular mark was first used by Gladding McBean in 1958 with their name appearing at the top of the rectangle where Interpace is seen here. The first mark was stamped in brown, the rest appear in black. The lines of the rectangle were also dashed instead of solid. In January 1963 no name appeared at the top as the firm had just become Interpace. The Interpace name first appears at the top of the mark in April 1963. The dashed line first becomes solid in 1966, used with heavier lettering on ceramics with dark glaze colors. The Franciscan name remains in the center throughout with various phrase from Earthenware, Masterpiece China, Family China, and Porcelain, to Cosmopolitan China, Whitestone Ware, and Discovery printed below it.[7]

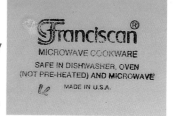

Franciscan marks by Interpace, c. 1976.

Franciscan Family China appears in the rectangle in 1958. Cosmopolitan China was made in Japan from 1959 to 1961 and "NTK Japan" appears within the line at the bottom of the rectangle. Discovery replaced Family China in December 1964.[8]

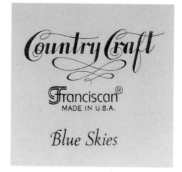

Circular Interpace mark dating from 1972. Gourmet was the pattern name.

Country Craft
Franciscan
MADE IN U.S.A.
Blue Skies

Interpace in Japan and England

Interpace had dining services produced in Japan from the 1960s onward in an effort to cut costs. A Japan sticker appears beneath each of these marks on "Fine Bone China," along with the pattern names Equus and Bridgeton.

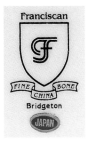

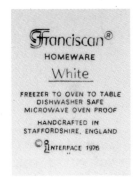

Printed Franciscan, Staffordshire England mark complete with Homeware pattern name, White color identification, Interpace name, and surprisingly a date ... 1976.

Impressed "F" mark from England. Interpace purchased potteries in England and was having wares produced there during the 1970s.

Franciscan Ceramics Inc.

Printed Franciscan mark, Bouquet pattern, used by Franciscan Ceramics Inc. (owned by Wedgwood Ltd.), 1980. The phrase "An Authentic Hand Decorated Classic" was first used by Interpace in 1977 and carried over by Franciscan Ceramics Inc.

Printed Franciscan, Staffordshire England mark with Apple pattern name, 1970s.

Chapter 4. Patterns

The patterns are organized in alphabetical order. Fortunately, although Franciscan pottery does not always carry manufacturers' marks listing each pattern name, each pattern was given a name by the company.

Acacia

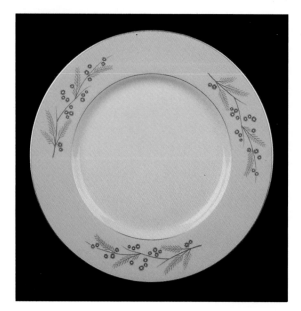

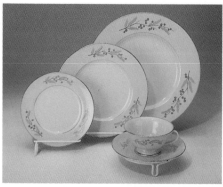

Acacia five piece place setting. Dinner plate (10 3/4" d.); salad plate (8 1/2" d.); bread and butter plate (6 3/8" d.); cup (2 1/4" h.) and saucer.

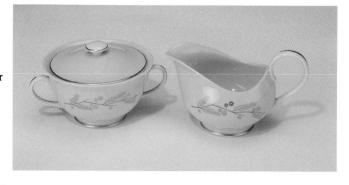

Acacia covered sugar bowl and creamer.

Almond Cream

Almond Cream dinner plate (11" d.), salad plate, cup and saucer.

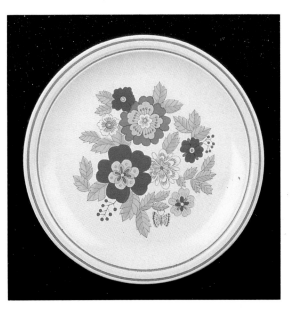

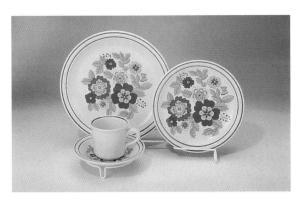

Alpine Meadow dinner plate (10 3/4" d.), salad plate (8 3/8" d.), cup (3 1/8" h.) and saucer.

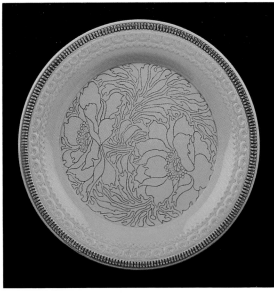

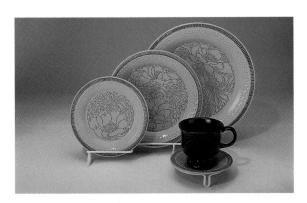

Amapola five piece place setting. Dinner plate (10 7/8" d.); salad plate (8 3/4" d.); bread and butter plate (6 7/8" d.); cup (3 1/2" h.) and saucer.

Angelica

Angelica five piece place setting. Dinner plate (10 3/4" d.); salad plate (8 1/4" d.); bread and butter plate (6 1/2" d.); cup (3 1/8" h.) and saucer.

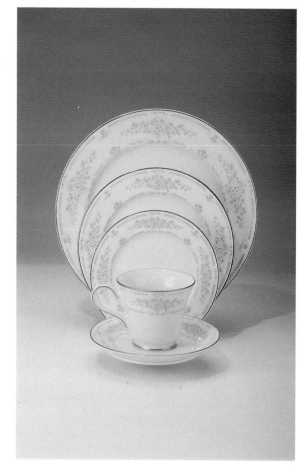

Antique

Antique dinner plate (10 3/8" d.).

Antique Green

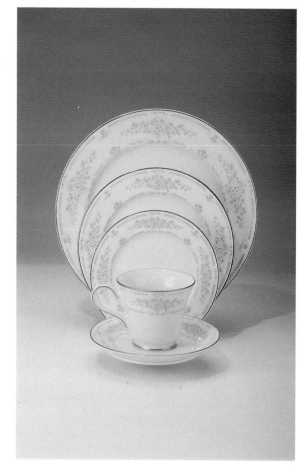

Antique Green dinner plate (10 1/2" d.), bread and butter plate (6 1/4" d.), cup (2" h.) and saucer.

Antique Green dinner plate. Note the embossed border design.

28

Apple ashtray (4 1/2" l.),
made in America.

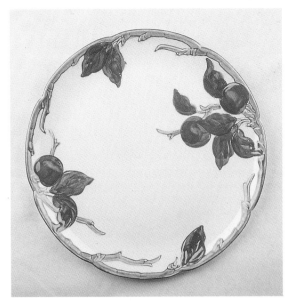

Apple round platter (12 5/8" d.), made
in America from 1940 onward.

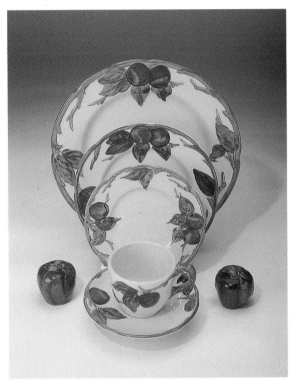

Apple place setting and apple shaped salt and pepper
shakers, made in America. Dinner plate (10 5/8" d.);
salad plate (8" d.); bread and butter plate (6 3/8" d.);
cup (2 3/4" h.) and saucer.

Apple tureens (7 1/2" & 8 1/2" h.)
and cookie jar (10 1/4" h.).

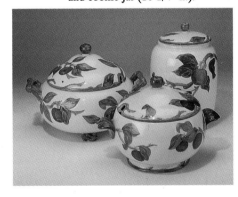

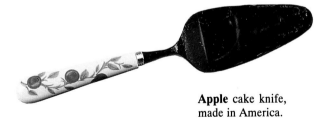

Apple cake knife,
made in America.

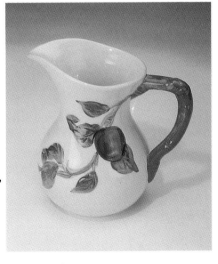

Apple pitcher (7" h.),
made in America.

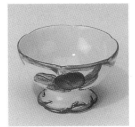

Apple small footed sherbet
bowl, made in America.

Apple
(English)

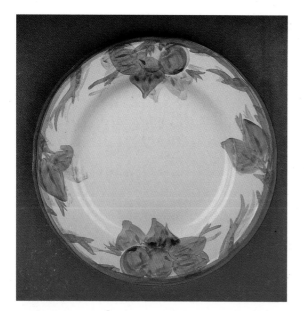

Apple five piece place setting, made in England. Dinner plate (10 3/4" d.); salad plate (7 7/8" d.); bread and butter plate (6 1/4" d.); cup (2 3/4" h.) and saucer.

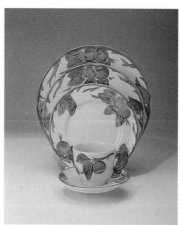

Appleton

Appleton dinner plate (10 1/2" d.), salad plate (8 1/4" d.), cup (1 3/4" h.) and saucer.

Applique

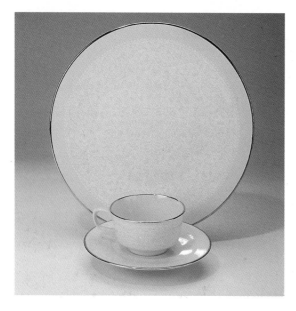

Applique dinner plate (10 1/2" d.) cup (2" h.) and saucer.

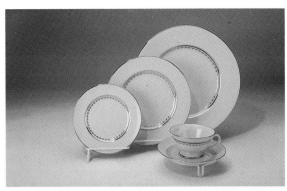

Arabesque

Arabesque five piece place setting. Dinner plate (10 3/4" d.); salad plate (8 3/8" d.); bread and butter plate (6 3/8" d.); cup (2 1/4" h.) and saucer.

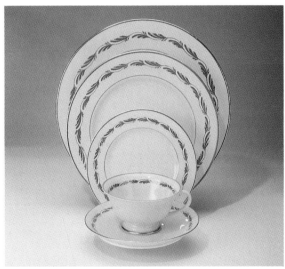

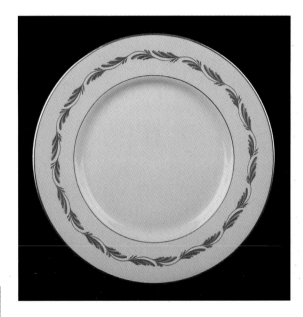

Arcadia Blue

Arcadia Blue five piece plate setting. Dinner plate (10 5/8" d.); salad plate (8 3/8" d.); bread and butter plate (6 1/4" d.); cup (2 1/4" h.) and saucer.

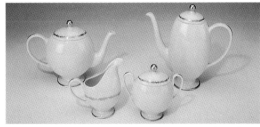

Arcadia Gold tea pot, creamer, covered sugar, and coffee pot.

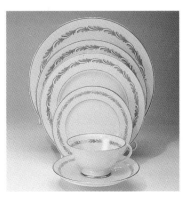

Arcadia Gold

Arcadia Gold five piece place setting. Dinner plate (10 5/8" d.); salad plate (8 3/8" d.); bread and butter plate (6 3/8" d.); cup (2 1/4" h.) and saucer.

Arcadia
Green

Arcadia Green five piece place setting. Dinner plate (10 3/4" d.); salad plate (8 3/8" d.); bread and butter plate (6 1/4" d.); cup (2 1/4" h.) and saucer.

Arcadia
Maroon

Arcadia Green dinner plate, cream soup bowl, salt and pepper shakers, cup and saucer.

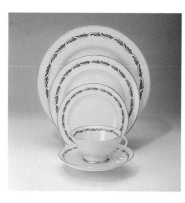

Arcadia Maroon five piece place setting. Dinner plate (10 5/8" d.); salad plate (8 3/8" d.); bread and butter plate (6 3/8" d.); cup (2 1/4" h.) and saucer.

Arden

Arden dinner plate (10 5/8" d.); salad plate (8 3/8" d.); bread and butter plate (6 3/8" d.); cup (2 1/4" h.) and saucer; cereal bowl (left); and fruit bowl (right).

Ariel dinner plate (10 1/2" d.); salad plate (8 1/4" d.); bread and butter plate (6 1/4" d.); cup (2 3/4" h.) and saucer; cereal bowl (left); and fruit bowl (right).

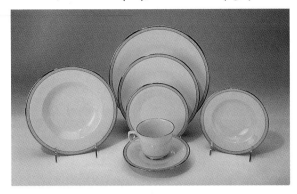

Ariel

Autumn

Autumn side salad (8 1/2" x 4 1/2").

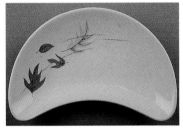

Autumn covered casserole and oil cruet.

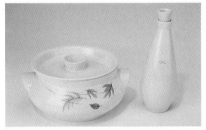

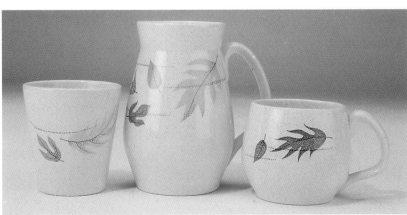

Autumn bread tray (17 7/8" l.)

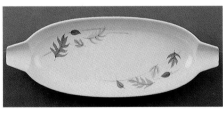

Autumn dinner plate, produced from 1955-1966.

Autumn mug (2 3/4" h.).

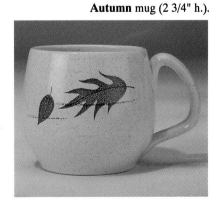

Autumn tumbler (handleless on left), large and small mugs.

33

Ballet

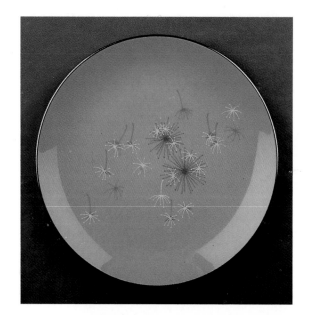

Ballet five piece place setting. Dinner plate (10 1/2" d.); salad plate (8 1/4" d.); bread and butter plate (6 3/8" d.); cup (1 5/8" h.) and saucer.

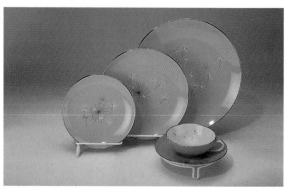

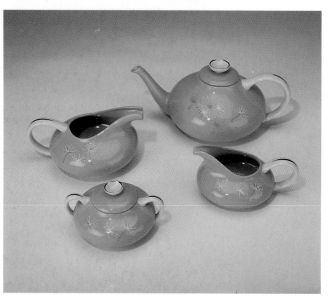

Ballet gravy boat (left), covered sugar bowl (bottom) creamer (4 7/8" h., right), and teapot (top).

Beverly

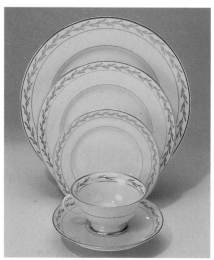

Beverly five piece place setting. Dinner plate (10 1/2" d.); salad plate (8 3/8" d.); bread and butter plate (6 3/8" d.); cup (2 1/4" h.) and saucer.

Bird N' Hand

Bird N' Hand dinner plate (10 3/8" d.), bread and butter plate (6 1/8" d.), cup (2 3/4" d.) and saucer.

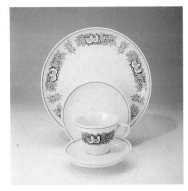

Bird N' Hand dinner plate by TKK Japan for Interpace, 1968.

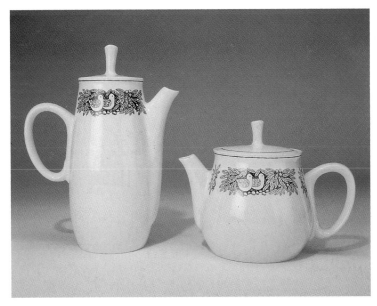

Bird N' Hand coffee pot and teapot.

Bittersweet

Bittersweet dinner plate (10 3/8" d.), salad plate (8 3/4" d.), cup (3 3/4" d.) and saucer.

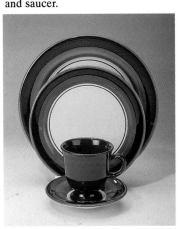

35

Blue Bell

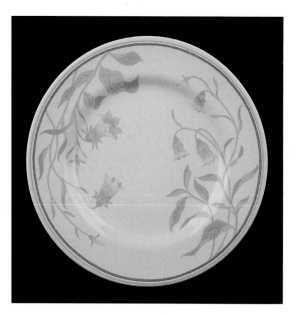

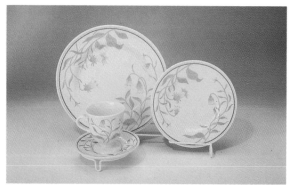

Blue Bell dinner plate (10 1/2" d.), salad plate (8 1/4" d.), cup and saucer.

Blue Dawn

Blue Dawn dinner plate (10 3/4" d.).

Blue Fancy

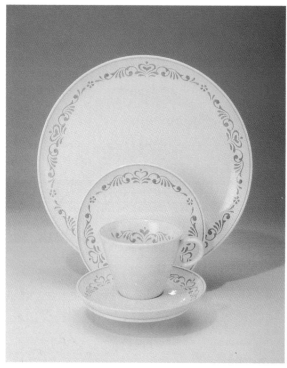

Blue Fancy dinner plate (10 1/4" d.), bread and butter plate (6" d.), cup (2 3/4" d.) and saucer.

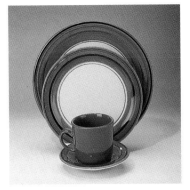

Blue Ribbon

Blue Ribbon dinner plate (10 7/8" d.), salad plate (8 7/8" d.), cup (3 1/4" h.) and saucer.

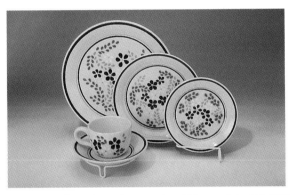

Blueberry

Blueberry five piece place setting. Dinner plate (10 7/8" d.), salad plate (8 1/4" d.), bread and butter plate (6 5/8" d.), cup (2 5/8" d.) and saucer.

Bountiful

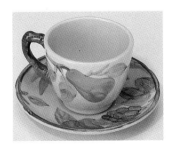

Bountiful saucer.

Bountiful cup (2 3/4" h.) and saucer.

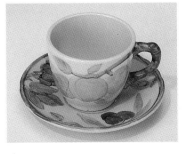

37

Bouquet
(Pattern 1)

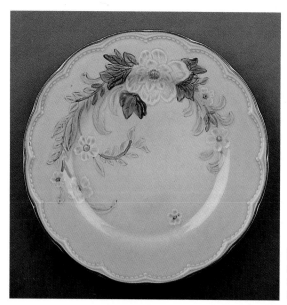

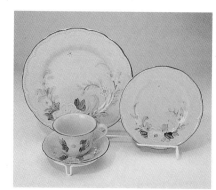

Bouquet dinner plate (10 5/8" d.), salad plate (8" d.), cup (2 3/4" h.) and saucer.

Bouquet dinner plate, one of two patterns, this one is applied to an earthenware body.

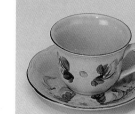

Bouquet cup and saucer.

Bouquet
(Pattern 2)

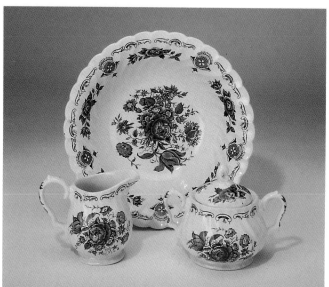

Bouquet bowl, creamer, and sugar bowl. The second of two patterns, this pattern applied to china.

Brentwood

Brentwood five piece place setting. Dinner plate (10 1/2" d.), salad plate (8 1/4" d.), bread and butter plate (6 3/8" d.), cup (1 5/8" h.) and saucer.

Bride's Bouquet

Bride's Bouquet dinner plate (9 7/8" d.), bread and butter plate (6 7/8" d.), sugar bowl, and creamer.

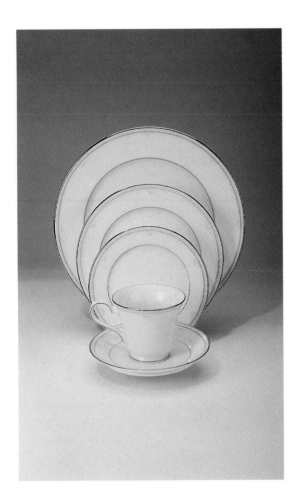

Bridgeton

Bridgeton five piece place setting. Dinner plate (10 3/4" d.), salad plate (8 1/8" d.), bread and butter plate (6 1/2" d.), cup (3" h.)

Cafe Royal

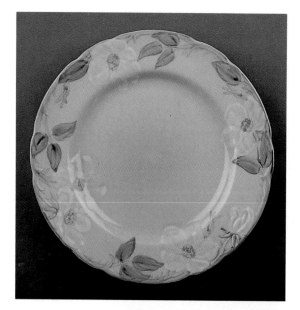

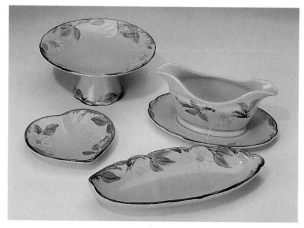

Cafe Royal platters (14" l. & 12 3/4" l. respectively).

Cafe Royal dinner plate (10 5/8" d.), luncheon plate (9 5/8" d.), salad plate (8" d.), cup (2 1/4" h.) and saucer.

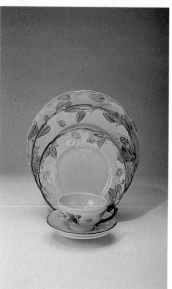

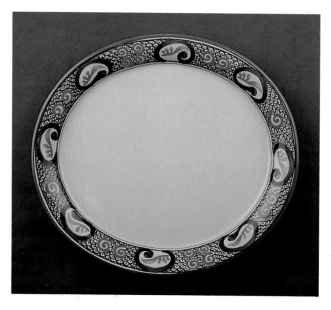

Cafe Royal heart shaped ashtray (left), comport (8" d., 4" h., top left) gravy boat with attached underplate (top right), and oval relish dish (11" l., bottom right).

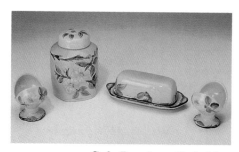

Cafe Royal candle holders (far left and far right), ginger jar, and a covered butter dish.

Calypso

Calypso platter (14" l.).

40

Cameo

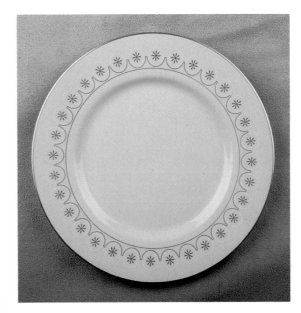

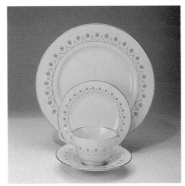

Cameo dinner plate (10 3/4" d.), bread and butter plate (6 1/2" d.), cup (2 1/2" h.) and saucer.

Cantata

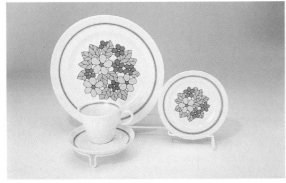

Cantata dinner plate (10 1/4" d.), bread and butter plate (6 1/8" d.), cup (2 3/4" h.) and saucer.

Canton salad plates (8 1/8" d.), top left, bottom right), bread and butter plate (6 3/8" d.), top right), cup (1 3/4" h.) and saucer, and fruit bowl (4 3/4" d., bottom left).

Canton

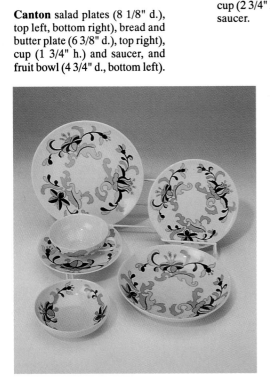

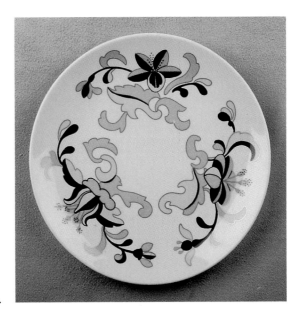

Canton salad plate.

41

Capri

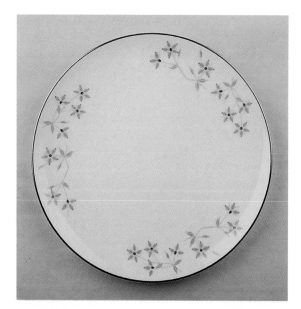

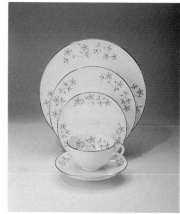

Capri five piece place setting. Dinner plate (10 1/4" d.); salad plate (8" d.); bread and butter plate (6 1/4" d.); cup (2 1/8" h.) and saucer.

Carmel

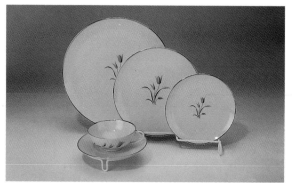

Carmel five piece place setting. Dinner plate (10 1/2" d.); salad plate (8 1/8" d.); bread and butter plate (6 3/8" d.); cup (1 5/8" h.) and saucer.

Castille

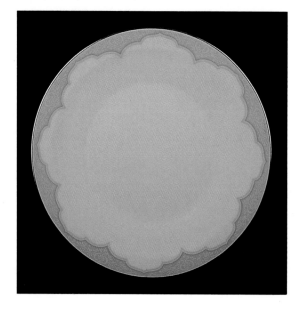

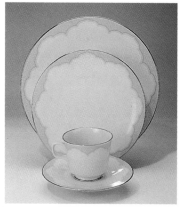

Castille dinner plate (10 1/2" d.), salad plate (8 1/4" d.), cup (2 3/4" h.) and saucer.

Chantilly

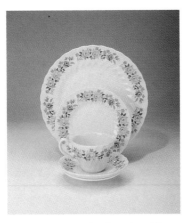

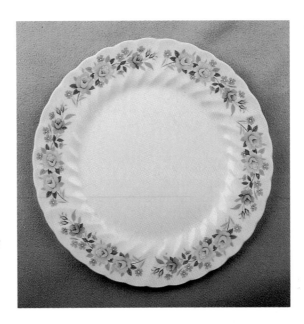

Chantilly dinner plate (9 7/8" d.), bread and butter plate (6 3/4" d.), cup (2 1/2" h.) and saucer.

Chelan

Chelan five piece place setting. Dinner plate (10 1/2" d.); salad plate (8 1/4" d.); bread and butter plate (6 3/8" d.); cup (2 1/8" d.) and saucer.

Cherokee Rose (First Variation)

Cherokee Rose five piece place setting with the wide inner gold band. Dinner plate (10 1/2" d.); salad plate (8 1/4" d.); bread and butter plate (6 3/8" d.); cup (2 1/4" h.) and saucer.

Cherokee Rose dinner plate. There are three variations of this pattern. This plate features a wide inner gold band. The second variation has a thin inner gold band; the third variation sports a wide inner green band.

Cherokee Rose
(Second Variation)

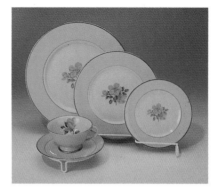

Cherokee Rose five piece place setting, the second variation with the thin inner gold band. Dinner plate (10 1/2" d.); salad plate (8 1/4" d.); bread and butter plate (6 1/8" d.); cup (2 1/4" h.) and saucer.

Cherokee Rose dinner plate, the second variation with the thin inner gold band.

Cherokee Rose
(Third Variation)

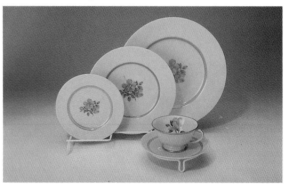

Cherokee Rose five piece place setting. Dinner plate (10 5/8" d.); salad plate (8 3/8" d.); bread and butter plate (6 1/4" d.); cup (2 3/8" h.) and saucer.

Cherokee Rose dinner plate, the third variation with the wide inner green band.

Chestnut

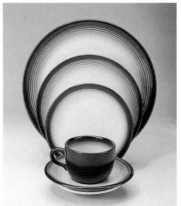

Chestnut five piece place setting. Dinner plate (10 3/4" d.); salad plate (8 1/4" d.); bread and butter plate (6 5/8" d.); cup (2 1/2" h.) and saucer.

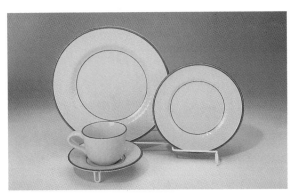

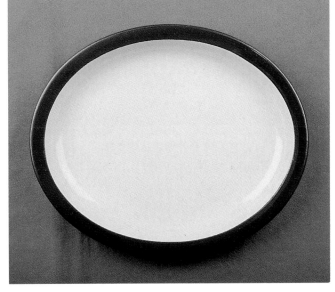

Chestnut Weave dinner plate (10 3/4" d.), salad plate (7 7/8" d.), cup (2 3/4" h.) and saucer.

Chestnut Weave dinner plate. Note the embossed weave pattern around the plate rim.

Chocolate

Chocolate platter (11 7/8" l.).

Christoval

Christoval sugar bowl, marked Franciscan Fine China.

Cimarron

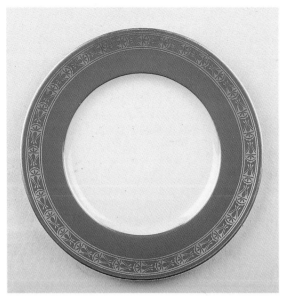

Cimarron salad plate.

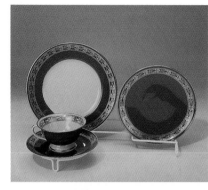

Cimarron salad plate (8 1/4" d.), bread and butter plate (6 3/8" d.), cup (2 1/4" h.) and saucer.

Cimarron coffee pot, creamer, sugar bowl, cream soup bowl (footed, double handled), and salt and pepper shaker.

Claremont

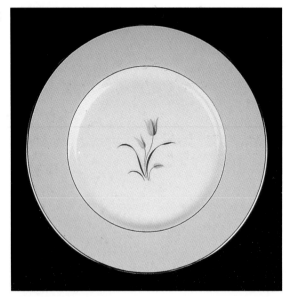

Claremont dinner plate (approx. 10 1/2" d.), salad plate (8 3/8" d.), cup (2 1/4" h.) and saucer.

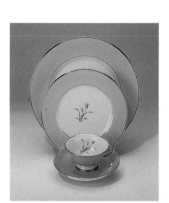

Cloud Nine

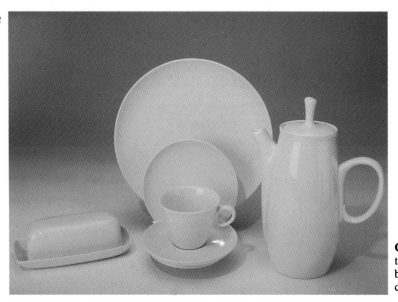

Cloud Nine is pure white with no pattern. Dinner plate (10 3/8" d.), bread and butter plate, cup (2 3/4" h.) and saucer, covered butter dish, and coffee pot.

Coaching Days salad plate.

Coaching Days

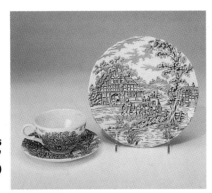

Coaching Days salad plate (7 7/8" d.), cup (2 1/2" h.) and saucer.

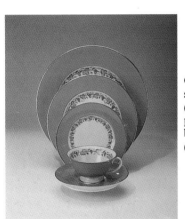

Concord five piece place setting. Dinner plate (approx. 10 1/2" d.); salad plate (8 1/4" d.); bread and butter plate (6 3/8" d.); cup (2 1/8" h.) and saucer.

Concord

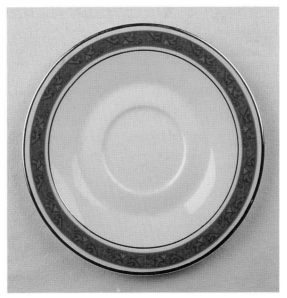

Concord sugar bowl and creamer.

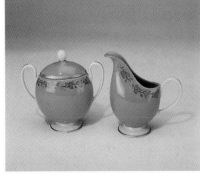

Constantine

Constantine saucer.

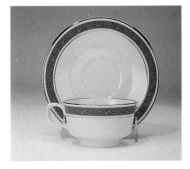

Constantine cup (2" h.) and saucer.

Contours

Contours art ware ashtray. This is a rare pattern with a gold backmark.

Corinthian

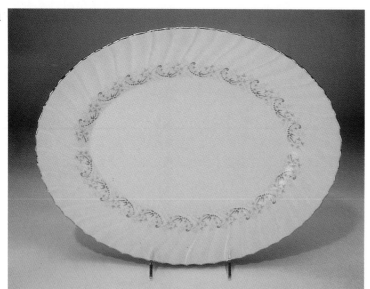

Corinthian five piece place setting. Dinner plate; salad plate; bread and butter plate; cup and saucer.

Corinthian platter (14" l.).

Corinthian cup and saucer.

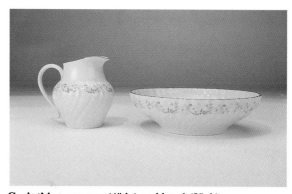

Corinthian creamer (4" h.) and bowl (8" d.).

Coronado, Aqua Glossy finish, salad plate. The Coronado pattern, also known as Swirl by some, came in a number of colors in both glossy and matte finishs. This table ware pattern was first released in 1936.

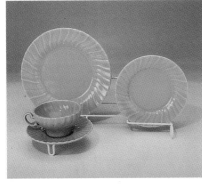

Coronado, Aqua Glossy finish, salad plate (8 1/4" d.), bread and butter plate (6 3/8" d.), cup (2 1/8" h.) and

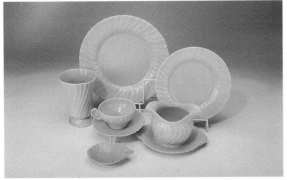

Coronado, Aqua Matte finish, dinner plate (10 1/2" d.), salad plate (8 1/8" d.), vase (5 1/2" h. on left), cup (2 1/8" h.) and saucer, gravy boat with attached underplate (right), and ashtray (front center).

Coronado, Burgundy glaze, salad plate (8 1/4" d.).

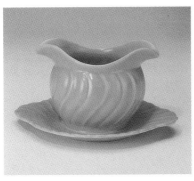

Coronado, Coral Glossy finish, gravy boat with attached underplate.

Coronado (Aqua, Glossy & Matte)

Coronado (Burgundy)

Coronado (Coral, Glossy)

Coronado, Coral Glossy finish, dinner plate (10 1/2" d.).

49

Coronado
(Coral, Matte)

Coronado, Coral Matte finish, salad plate (8 1/8" d.).

Coronado, White Glossy finish, dinner plate (10 3/8" d.).

Coronado
(White, Glossy & Matte)

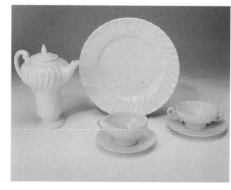

Coronado, White Matte finish, coffee pot, dinner plate (10 3/8" d.), cup and saucer (bottom center), cream soup and saucer (right).

Coronado, White Matte finish, dinner plate.

Coronado
(Yellow, Glossy)

Coronado, Yellow Glossy finish, dinner plate.

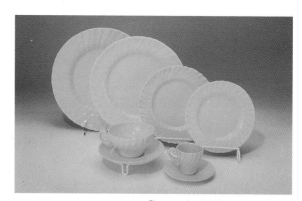

Coronado, Yellow Glossy finish, chop plate (far left, 11 5/8" d.), dinner plate (10 1/2" d.), luncheon plate (9 1/2" d.), salad plate (8 1/8" d.), cup (2 1/4" h.) and saucer, and demi tasse cup and saucer.

Coronado, Yellow Matte finish, dinner plate (10 1/4" d.).

Coronado (Yellow, Matte)

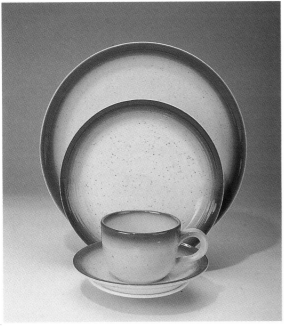

Country Craft, Almond Cream color trim, dinner plate (11" d.), salad plate (8 3/8" d.), cup (2 5/8" h.) and saucer.

Country Craft, Almond Cream

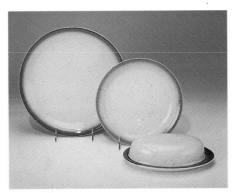

Country Craft, Blue Skies color trim, dinner plate (11" d.), salad plate (8 1/2" d.), covered butter dish.

Country Craft, Blue Skies

Country Craft, Peachy Pink

Country Craft, Peachy Pink color trim, dinner plate (11" d.), salad plate (8 1/2" d.), and bowl.(6 1/2" d.).

Country Craft, Russet Brown

Country Craft, Russet Brown color trim, dinner plate (10 7/8" d.).

Country French

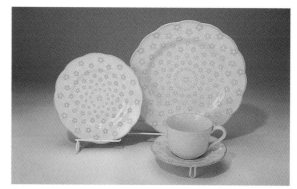

Country French dinner plate (10 1/2" d.), salad plate (7 7/8" d.), cup (2 1/2" h.) and saucer.

Countryside salad plate. This pattern was printed in two variations, blue or red scenery on white.

Countryside

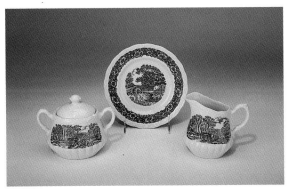

Countryside salad plate (7" d.), sugar bowl, and creamer.

Creole

Creole round covered casserole (10" d. inside). Note the embossed design around the edge of the lid.

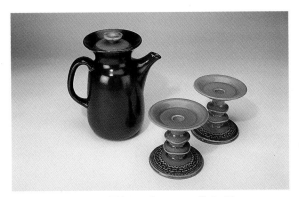

Creole coffee pot (10" h.) and two candle holders.

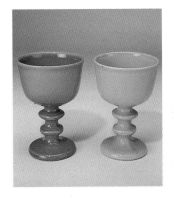

Creole (left) and **Amapola** goblets. Watch out for patterns which are very similar on the same body shape. These can cause confusion.

Crinoline
(Pattern 1)

Crinoline salad plate (8 3/8" d.). There are two Crinoline patterns. The first, and earliest pattern, features small pink flowers with a pink and blue ribbon. The second has yellow flowers. Both are printed on china.

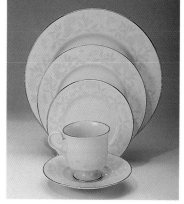

Crinoline five piece place setting. The second (and later) pattern on china, decorated with yellow flowers. Dinner plate (10 1/2" d.); salad plate (8 1/4" d.); bread and butter plate (6 3/8" d.); cup (3 1/4"h.) and saucer.

Crinoline
(Pattern 2)

Crown
Jewel
(far right)

Crinoline dinner plate printed on Masterpiece China.

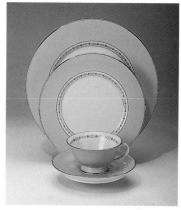

Crown Jewel dinner plate (10 3/4" d.), salad plate (8 1/4" d.), cup (2 1/8" d.), and saucer.

Cypress

Cypress dinner plate (10 3/8" d.), salad plate, cup and saucer, and gravy boat with underplate.

54

Daffodil salad plate (8" d. on left), cereal bowl (7 1/4" d. on right), cup (3 3/4" h.) and saucer.

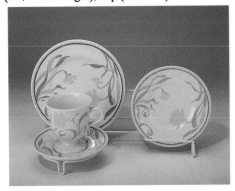

Daisy dinner plate (10 1/2" d.), bread and butter plate (6 1/2" d.), cup (2 1/8" h.) and saucer.

Daisy teapot (top left), oval divided vegetable dish (13 7/8" l., bottom left), gravy boat with underplate (center), tumbler (handleless, 3 3/8" h., right).

Daisy

Daisy Wreath

Daisy Wreath five piece place setting. Dinner plate (10 5/8" d.), salad plate (8" d.), bread and butter plate (6 1/2" d.), cup (3 3/4" h.) and saucer.

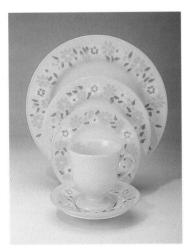

Dawn

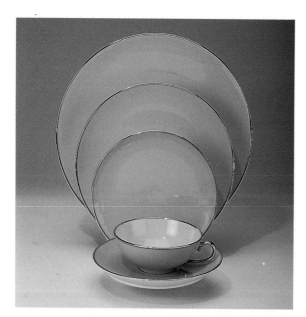

Dawn five piece place setting. Dinner plate (10 1/2" d.); salad plate (8 1/4" d.); bread and butter plate (6 3/8" d.); cup (1 5/8" h.) and saucer.

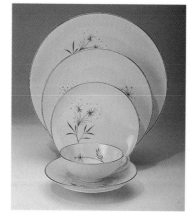

Debut

Debut five piece place setting. Dinner plate (10 1/2" d.); salad plate (8 1/4" d.); bread and butter plate (6 3/8" d.); cup (1 3/4" h.) and saucer.

Del Mar
(far right)

Del Monte

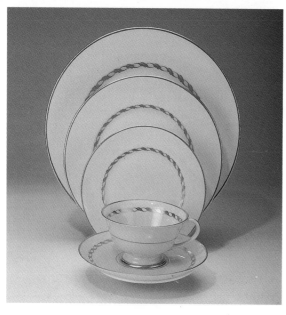

Del Mar coffee pot, covered butter dish, and round covered vegetable dish (10" d.), 1937.

Del Monte five piece place setting. Gold twisted rope decoration along inner rim and gold trim outer rim. Dinner plate (10 5/8" d.); salad plate (8 1/4" d.); bread and butter plate (6 3/8" d.); cup (2 1/4" h.) and saucer.

Del Rio five piece place setting. Dinner plate (10 5/8" d.); salad plate (8 1/4" d.); bread and butter plate (6 1/4" d.); cup (2 1/8" h.) and saucer.

Del Rio

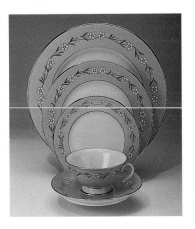

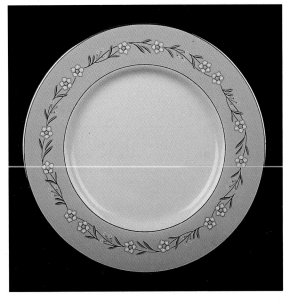

Desert Rose
(American)

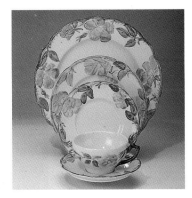

Desert Rose five piece place setting. Dinner plate (10 5/8" d.); salad plate (8" d.); bread and butter plate (6 3/8" d.); cup (2 1/4" h.) and saucer.

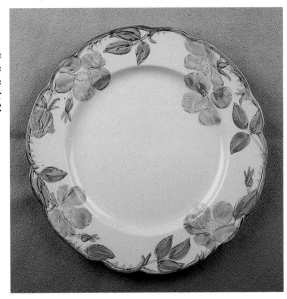

Desert Rose soup tureen (7 1/2" h.) and cookie jar (10 1/2" h.).

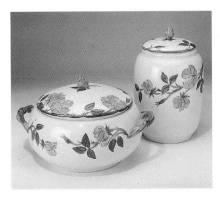

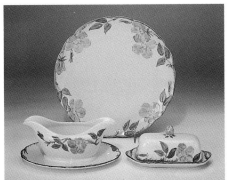

Desert Rose bowl (6" d. x 1 1/2" h.).

Desert Rose round chop plate (11 1/2" d.), gravy boat with attached underplate, and covered butter dish.

57

Desert Rose
(American)

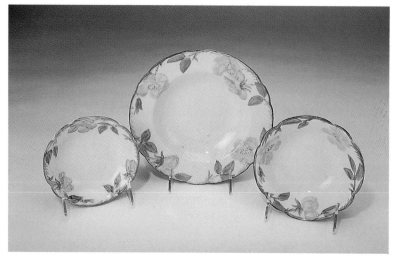

Desert Rose fruit bowl (5 1/4" d., left), soup bowl (8 1/2" d.), and cereal bowl (6" d.).

Desert Rose napkin rings, rectangular relish dish (10 3/8" l.), and comport (8" d. x 3 3/4" h.).

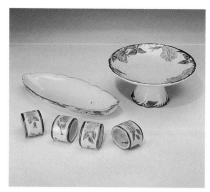

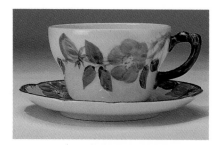

Desert Rose jumbo cup and saucer (cup 4 1/2" d. x 3" h., saucer 7" d.).

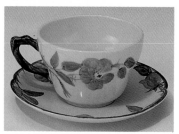

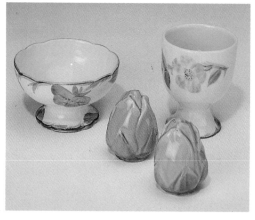

Desert Rose sherbet dish (4" d. x 2 1/2" h., left), egg cup (2 3/4" d. x 3 3/4" h.), and two salt and pepper shakers in the shape of rose buds (2 1/4" h.).

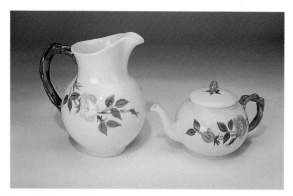

Desert Rose pitcher and teapot (4" h.).

Desert Rose ash tray, hand painted (3 1/2" d.).

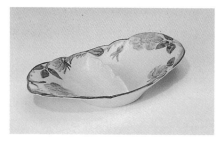

Desert Rose ashtray (9" l.).

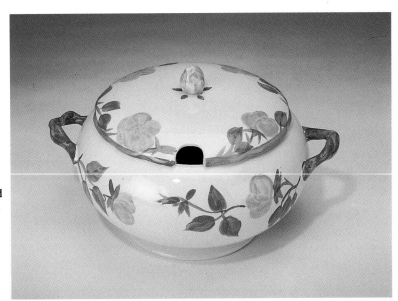

Desert Rose (English)

Desert Rose footed soup tureen (5 3/4" h.).

Desert Rose square salad plate (7 1/2" d.) and spoon holder (6 3/4" l.).

Desert Rose footed vase (10 3/4" h.) and utensil holder (6 3/4" h.).

Dogwood

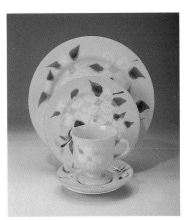

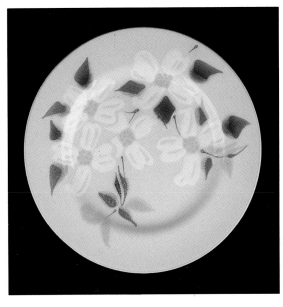

Dogwood dinner plate (10 5/8" d.), salad plate (8" d.), cup (3 7/8" h.) and saucer.

Duet

Duet dinner plate (10 3/4" d.), bread and butter plate (6 1/2" d.), cup (2 3/8" h.) and saucer.

Duet dinner plate, 1956.

Duet platter (13 1/8" d.) and three section relish dish (9" d.).

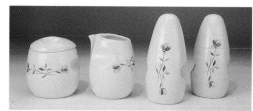

Dutch Weave

Duet sugar bowl, creamer, and salt and pepper shakers.

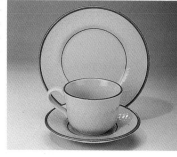

Dutch Weave bread and butter plate. Note the embossed weave pattern in the rim.

D u t c h W e a v e bread and b u t t e r plate, cup (2 3/4" h.) and saucer.

Echo

Echo dinner plate, listed as oven safe, (10 1/2" d.) and two pitchers (8 1/4" & 9 7/8" h.).

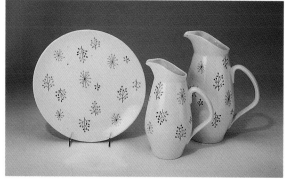

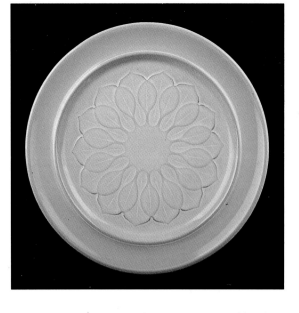

El Dorado dinner plate (10 5/8" d.), round vegetable dish (8 1/2" d.), cup (3 1/8" h.) and saucer.

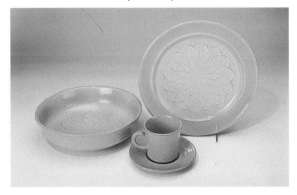

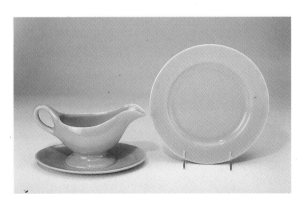

El Patio, Aqua, Glossy finish, gravy boat and underplate and salad plate (8 1/4" d.).

El Patio, Aqua, Matte finish, dinner plate.

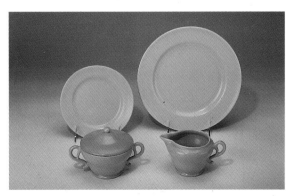

El Patio, Aqua, Matte finish, bread and butter plate (6 3/8" d.), dinner plate (10 1/2" d.), sugar bowl, and creamer.

61

**El Patio
(Coral,
glossy)**

El Patio, Coral, Glossy finish, dinner plate (10 1/2" d.), bread and butter plate (6 1/2" d.), cup (2 1/4" h.) and saucer.

El Patio, Grey, Glossy finish, platter (13 1/4" l.).

**El Patio
(Grey,
Matte &
Glossy)**

El Patio, Grey, Matte finish, platter (11 1/2" l.).

**El Patio
(Yellow,
Matte &
Glossy)**

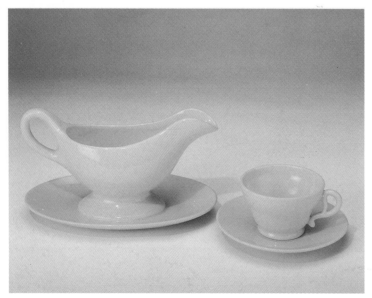

El Patio, Yellow, Matte finish, gravy boat with attached underplate.

El Patio, Yellow, Glossy finish, gravy boat, cup (2 1/4"h.) and saucer.

El Patio, Pale Yellow, Matte finish, dessert plate (7 3/8" d.).

62

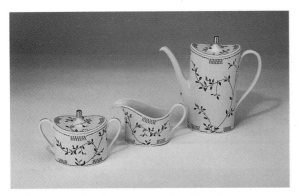

Elsinore

Elsinore sugar bowl, creamer, and coffee pot.

Elsinore dinner plate (10 1/2" d.).

Emerald Isle

Emerald Isle dinner plate (10 3/8" d.), salad plate (8 3/8" d.), cup (2 1/4" d.) and saucer, and mug (4 1/4" h.).

Encanto Rose

Encanto Rose platter (16 1/4" d.), oval vegetable bowl (8 3/4" d.), cup (1 3/4" h.) and saucer. An example of Franciscan Masterpiece China.

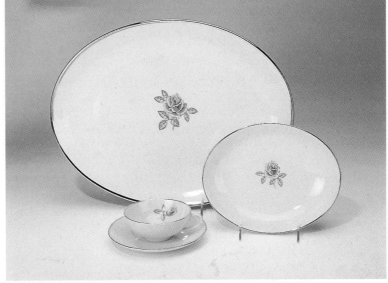

Encanto White

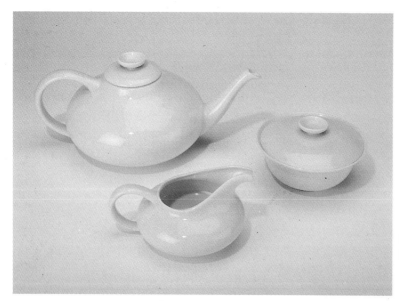

Encanto White teapot, creamer, and sugar bowl.

Encore

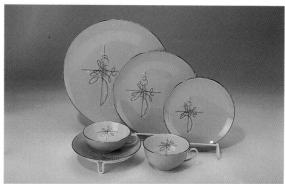

Encore five piece place setting. Dinner plate (10 1/2" d.); salad plate (8 1/8" d.); bread and butter plate (6 3/8" d.); cup (1 3/4" h.) and saucer.

Equus

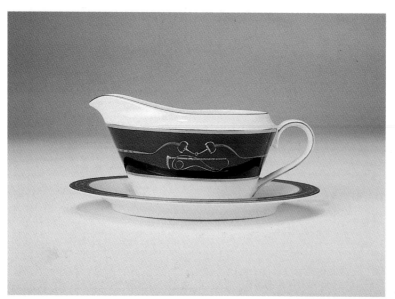

Equus gravy boat and underplate.

Erica

Erica cereal bowl (6 1/2" d.), cup (2 1/4" h.) and saucer, and glass tumbler (6 1/4" h.).

Erica saucer.

Fan Tan

Fan Tan platter (13 1/4" d.), bread and butter plate (6" d.), and covered butter dish.

Ferndel side salad.

Ferndel dinner plate. Marked "Oven Safe," 1957.

Ferndel

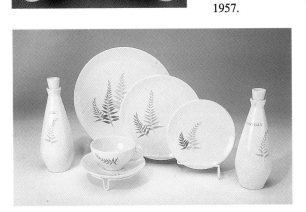

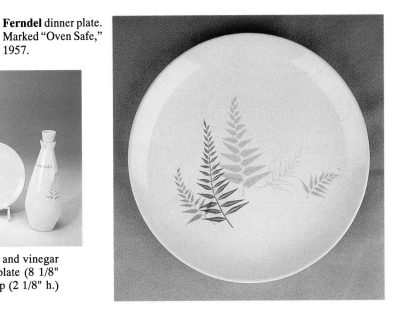

Ferndel five piece place setting, plus oil and vinegar cruets. Dinner plate (10 1/2" d.), salad plate (8 1/8" d.), bread and butter plate (6 1/2" d.), cup (2 1/8" h.) and saucer, oil and vinegar cruets (9" h.).

Fire Dance

Fire Dance salad plate (8 3/4" d.).

Floral

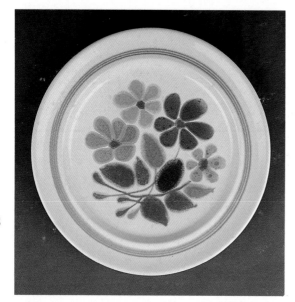

Floral five piece place setting. Dinner plate (10 1/2" d.), salad plate (8 1/2" d.), bread and butter plate, cup (3 1/4" h.) and saucer.

Floral Sculptures (Lotus, far right)

Floral Sculptures (Dahlia)

Floral Sculptures, Lotus, green, dinner plate. All of the flower patterns are pressed into the plate surfaces. All of the dinner plates measure 10 5/8" d.

Floral Sculptures, Dahlia, orange, dinner plate.

66

Floral Sculptures, Rose, yellow, dinner plate.

Floral Sculptures (Rose)

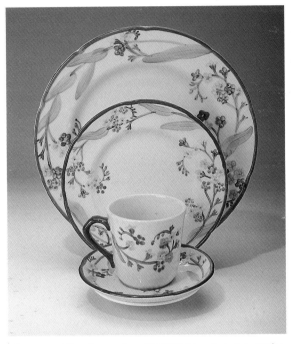

Forget-Me-Not dinner plate (10 3/4" d.), salad plate (8" d.), cup (3 1/4" h.) and saucer.

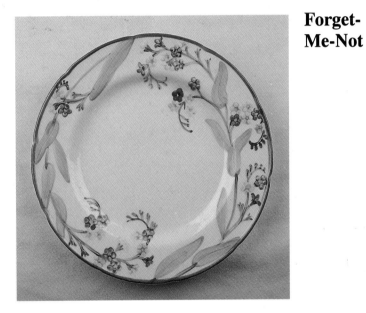

Forget-Me-Not

Fremont five piece place setting. Dinner plate (10 5/8" d.); salad plate (8 3/8" d.); bread and butter plate (6 3/8" d.), cup (2 1/4" h.) and saucer.

Fremont

French Floral

French Floral dinner plate (10 1/2" d.), salad plate (7 7/8" d.), cup (2 3/4" h.) and saucer.

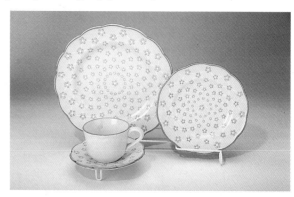

Fresh Fruit

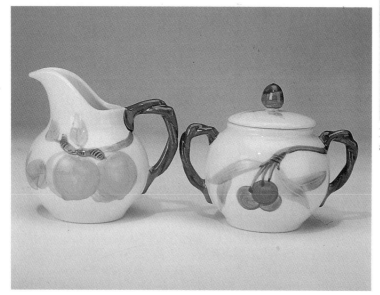

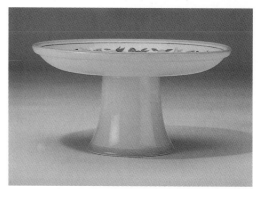

Fresh Fruit creamer (4 1/2" h.) and sugar bowl (4" h.).

Fruit (small)

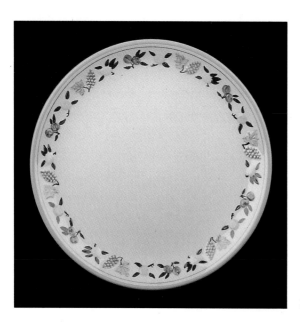

Fruit ("Old Fruit") comport, hand painted (7" d.).

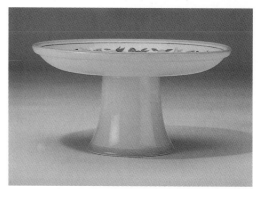

Fruit dinner plate (10 7/8" d.).

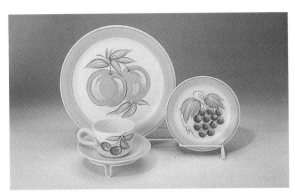

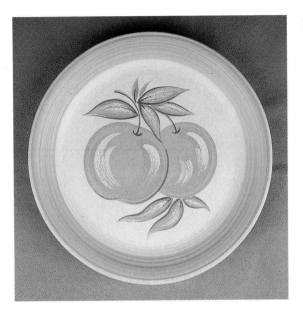

Fruit

Fruit dinner plate (10 1/2" d.), bread and butter plate (6 3/8" d.), cup (2 1/4" h.) and saucer.

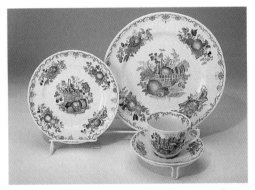

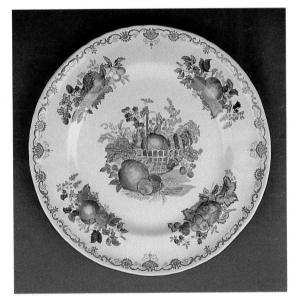

Fruit Basket

Fruit Basket dinner plate (10 1/2" d.), salad plate (7 3/4" d.), cup (2 3/4" h.) and saucer.

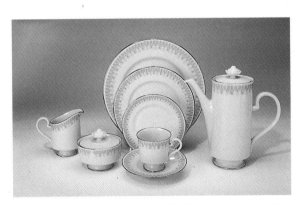

Gabrielle

Gabrielle five piece place setting, creamer, sugar bowl, and coffee pot. Dinner plate (10 5/8" d.); salad plate (8 1/4" d.); bread and butter plate (6 1/4" d.); cup (3 1/4" h.) and saucer.

Garden Party

Garden Party platter (14 1/2" d.).

Gingersnap

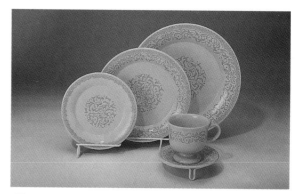

Gingersnap five piece place setting. Dinner plate (10 3/4" d.); salad plate (8 3/4" d.); bread and butter plate (6 7/8" d.); cup (3 3/8" d.) and saucer.

Glen Field

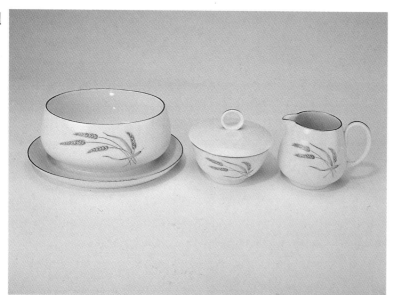

Glen Field gravy boat with attached underplate, sugar bowl, and creamer.

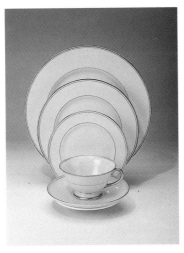

Gold Band five piece place setting. Dinner plate (10 1/2" d.); salad plate (8 1/4" d.); bread and butter plate (6 3/8" d.); cup (2 1/4" h.) and saucer.

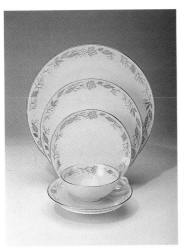

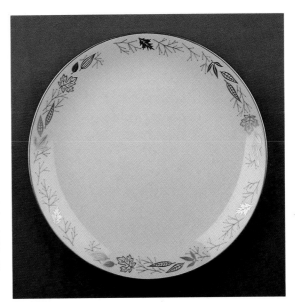

Gold Leaves

Gold Leaves five piece place setting. Dinner plate (10 3/8" d.); salad plate (8 1/8" d.); bread and butter plate (6 3/8" d.); cup (1 5/8" h.) and saucer.

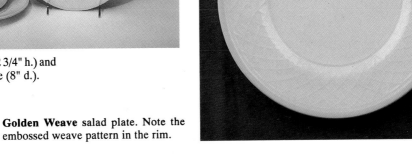

Golden Weave

Golden Weave cup (2 3/4" h.) and saucer and salad plate (8" d.).

Golden Weave salad plate. Note the embossed weave pattern in the rim.

Gourmet

Gourmet salad plate (8 1/2" d.).

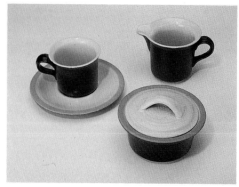

Gourmet cup (3 1/8" h.) and saucer, creamer, and sugar bowl.

Granada

Granada salad plate (8 1/4" d.), bread and butter plate (6 1/4" d.), cup (2 1/2" d.) and saucer.

Granville

Granville sugar bowl, marked Franciscan Fine Bone China, Japan.

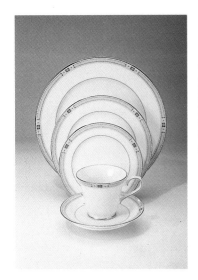

Greyson five piece place setting. Dinner plate (10 3/4" d.); salad plate (8 1/4" d.); bread and butter plate (6 3/8" d.); cup (3 1/8" h.) and saucer.

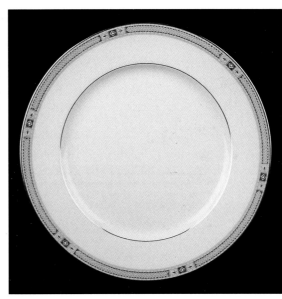

Greenhouse

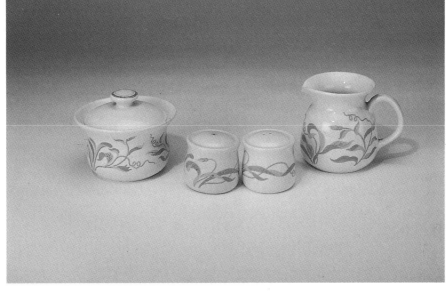

Greenhouse sugar bowl, salt and pepper shaker, and creamer (4" h.).

Hacienda
(Gold)

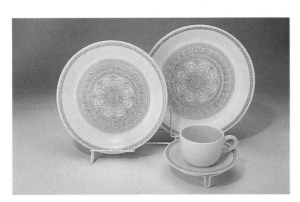

Hacienda, Gold, dinner plates (10 3/4" d.), cup (2 5/8" h.) and saucer.

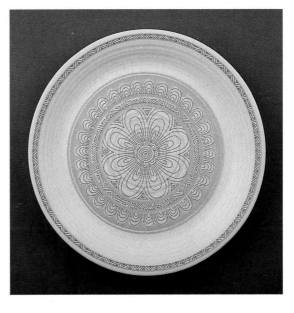

Hacienda
(Green)

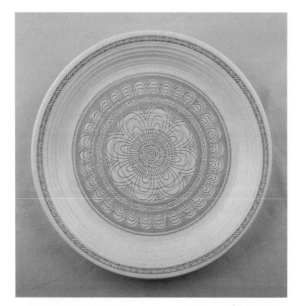

Hacienda, Green, five piece place setting. Dinner plate (10 7/8" d.); salad plate (8 3/8" d.); bread and butter plate (6 5/8" d.); cup (2 1/2" h.) and saucer.

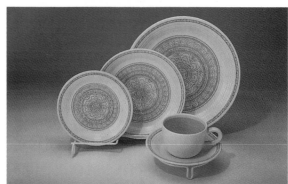

Happy Talk

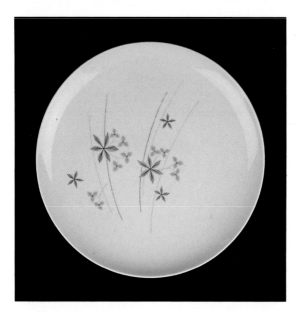

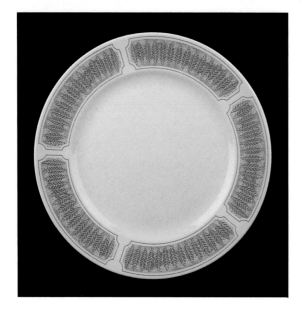

Happy Talk five piece place setting. Dinner plate (10 1/4" d.); salad plate (8 1/4" d.); bread and butter plate (6 1/4" d.); cup (2 3/4" h.) and saucer.

Hawaii

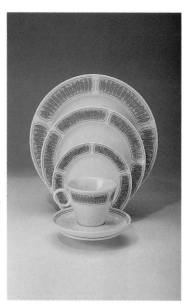

Hawaii five piece place setting. Dinner plate (10 1/4" d.); salad plate (8 1/4" d.); bread and butter plate (6 1/8" d.); cup (2 5/8" h.) and saucer.

Heritage salt & pepper shaker (3" h.) and covered butter dish (6" l.).

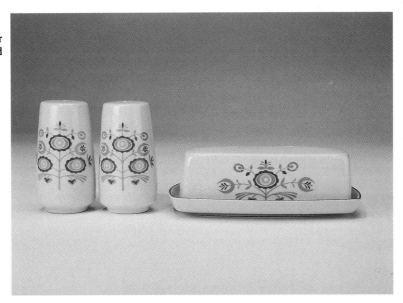

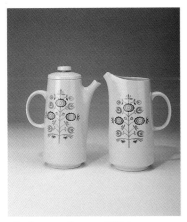

Heritage coffee pot (9" h.) and pitcher (8 1/2" h.).

Homeland dinner plate (10" d.), bread and butter plate (6 7/8" d.), cup (2 3/8" h.) and saucer.

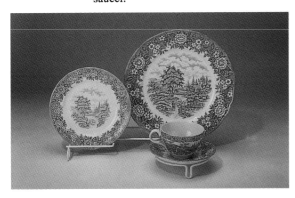

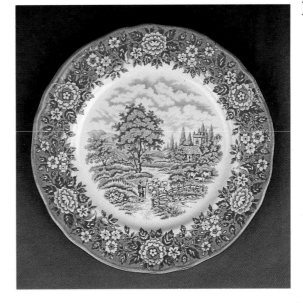

Homeware, White, dinner plate, marked Staffordshire, England, Interpace, 1976. Oven, dishwasher, and microwave safe. Note the embossed vine design.

Homeware, White, dinner plate (10 1/2" d.), bread and butter plate (7" d.), cup (3 1/2" d.) and saucer.

75

Honey Dew

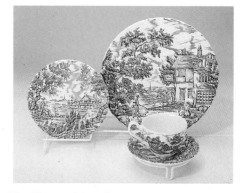

Honey Dew five piece place setting. Dinner plate (10 3/4" d.); salad plate (8 3/8" d.); bread and butter plate; cup (2 5/8" h.) and saucer.

The Hunter (Blue)

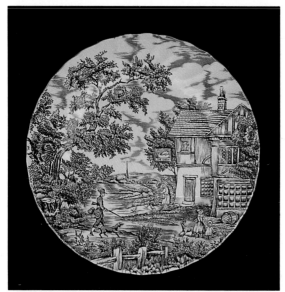

The Hunter, blue transfer print, dinner plate.

The Hunter, blue, dinner plate (10" d.), bread and butter plate (6 7/8" d.), cup (2 5/8" h.) and saucer.

The Hunter (Multi-colored)

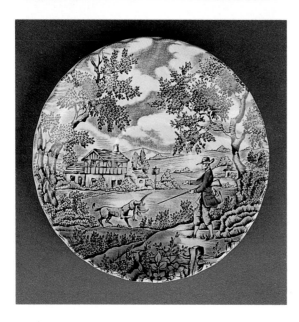

The Hunter, multi-colored, cup (2 5/8" h.) and saucer and cereal bowl (6 1/4" d.).

The Hunter, multi-colored transfer print, saucer, marked Staffordshire England.

76

Huntington five piece place setting. Dinner plate (10 5/8" d.); salad plate (8 3/8" d.); bread and butter plate (6 3/8" d.); cup (2 1/4" h.) and saucer.

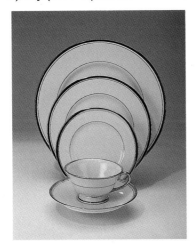

Huntington

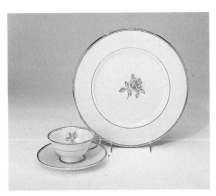

Huntington Rose dinner plate (10 3/4" d.), cup (2 1/4" h.) and saucer.

Huntington Rose dinner plate, marked Masterpiece China.

Huntington Rose

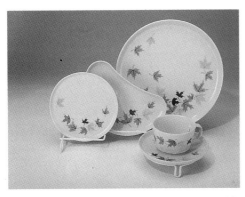

Indian Summer dinner plate (10 1/8" d.), side salad (8" d.), bread and butter plate (6 1/8" d.), cup (2 1/4" h.) and saucer.

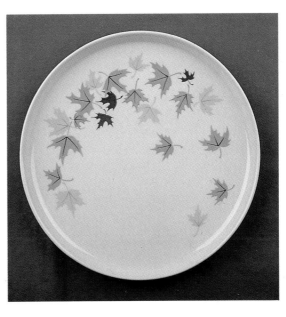

Indian Summer

Indigo

Indigo five piece place setting. Dinner plate (10 3/8" d.); salad plate (8 1/4" d.); bread and butter plate (6 1/4" d.); cup (2 3/4" h.) - saucer missing.

Interlude

Interlude five piece place setting. Dinner plate (10 1/2" d.); salad plate (8 1/4" d.); bread and butter plate (6 3/8" d.); cup (2" h.) and saucer.

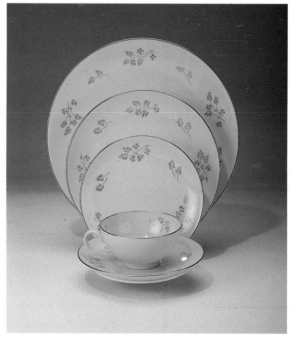

Intrigue

Intrigue dinner plate (10 1/2" d.) with a very thin blue trim line.

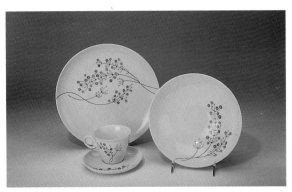

It's A Breeze dinner plate (10 3/8" d., left), round vegetable bowl (8 1/4" d., right), cup (2 3/4" h.) and saucer.

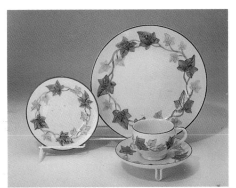

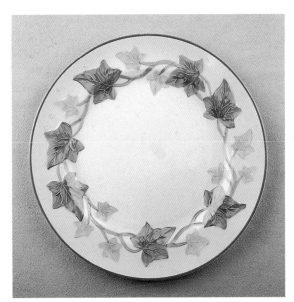

Ivy dinner plate (10 3/8" d.), bread and butter plate (6 3/8" d.), cup (2 5/8" h.) and saucer.

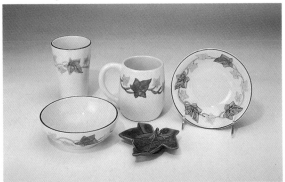

Ivy tumbler (5" h., upper left), fruit bowl (5 3/8" d., lower left), mug (4 1/2" h.), ivy leaf shaped ashtray (4 1/2" w., bottom center), and saucer.

Ivy tidbit dish with a brass center spindle and brass foot.

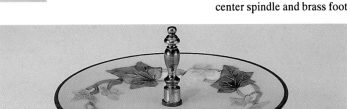

Jamocha

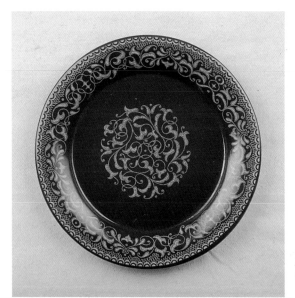

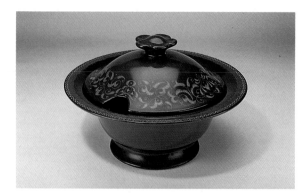

Jamocha huge brown soup tureen (15 1/2" d., 10" h.).

Jamocha salad plate.

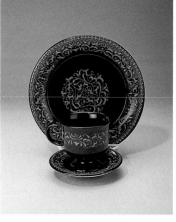

Jamocha salad plate (8 7/8" d.), cup (3 1/2" h.) and saucer.

Kasmir

Kasmir platter (13" l.).

Kismet

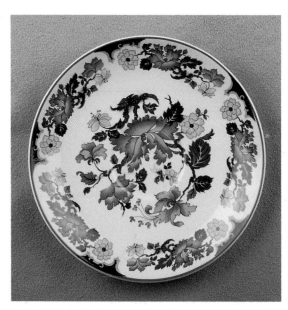

Kismet cup (2 1/4" h.) and saucer.

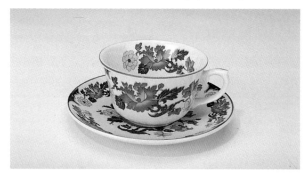

Kismet saucer (6" d.), marked Myott-Meakin, England.

Laguna bread and butter plate.

Laguna

Laguna bread and butter plate (6 1/4" d.), cup (2 1/4" h.) and saucer.

Larkspur

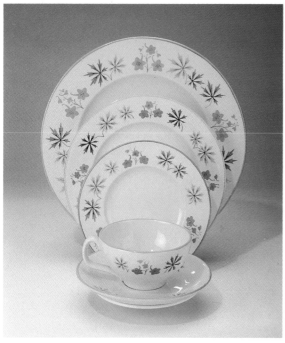

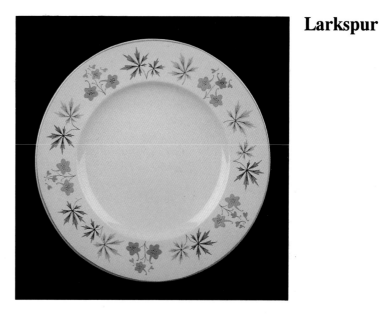

Larkspur five piece place setting. Dinner plate (10 1/2" d.); salad plate (8 1/8" d.); bread and butter plate (6 1/2" d.); cup (2 1/4" h.) and saucer.

Lattice

Lattice dinner plate (10 5/8" d.). Note that this has the same embossed weave pattern in the rim as Dutch Weave and Golden Weave without the colored edge.

Leeds

Leeds dinner plate. Marked Staffordshire England.

Leeds dinner plate (10" d.), bread and butter plate (6 7/8" d.), cup (2 3/4" h.) and saucer.

Lorraine
(Green)

Lorraine, Green, salad plate (8 1/4" d.).

Lorraine
(Maroon)

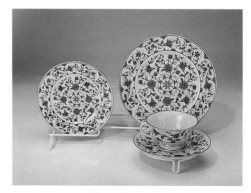

Lorraine, Maroon, salad plate (8 3/8" d.), bread and butter plate (6 3/8" d.), cup (2 1/4" d.) and saucer.

Lorraine, Maroon, salad plate.

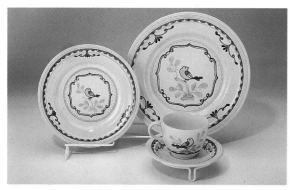

Lovebird

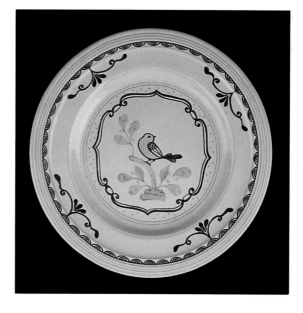

Lovebird dinner plate (10 1/2" d.), salad plate (8 1/4" d.), cup (3 1/2" d.) and saucer (6" d.).

Lucerne dinner plate with a blue crossed fronds border.

Lucerne

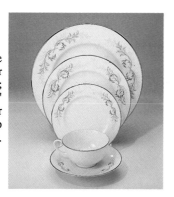

Lucerne five piece place setting. Dinner plate (10 3/4" d.); salad plate (8 3/8" d.); bread and butter plate (6 3/8" d.); cup (2 1/8" h.) and saucer.

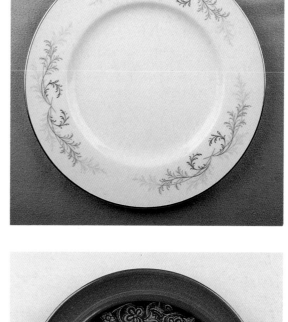

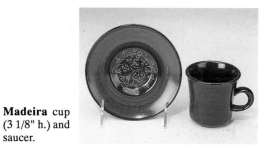

Madeira oval platter (13 1/2" d.).

Madeira

Madeira dinner plate (10 1/2" d.).

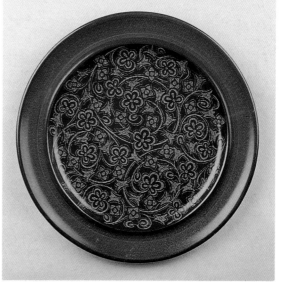

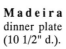

Madeira cup (3 1/8" h.) and saucer.

Madrigal

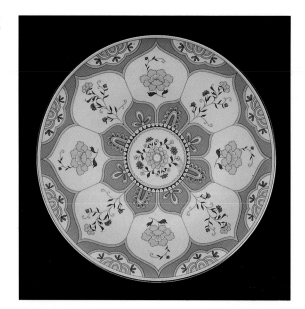

Madrigal dinner plate, cup (3 1/2"h.) and saucer.

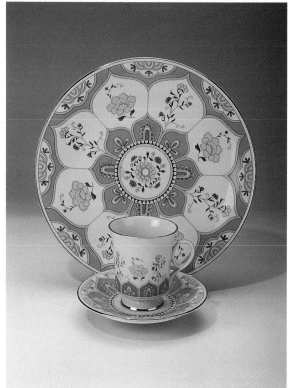

Magnolia

Magnolia dinner plate (12 1/2" d.).

Malaya

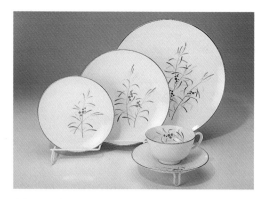

Malaya five piece place setting. Dinner plate (10 1/4" d.); salad plate; bread and butter plate (6 3/4" d.); cup (2 1/2" h.) and saucer.

Malibu

Malibu oval serving platter. (12 5/8" d.)

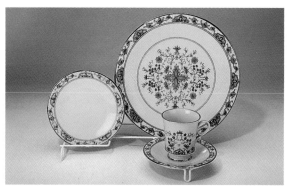

Mandalay
(Pattern 1)

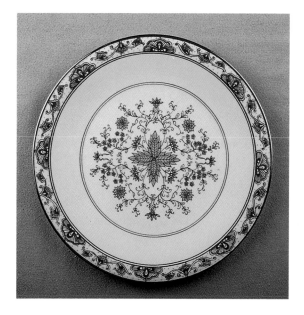

Mandalay dinner plate, bread and butter plate (6 3/4" d.), cup (3 1/2" h.) and saucer.

Mandalay
(Pattern 2)

Mandalay oblong serving platter (14 3/4" d.).

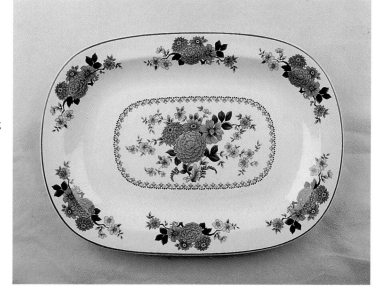

Mandarin

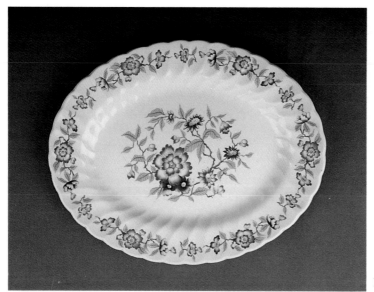

Mandarin oval serving platter (12 3/8" d.), sugar bowl, and creamer.

Mandarin oval serving platter.

Mariposa

Mariposa chop plate (13 1/2" d.).

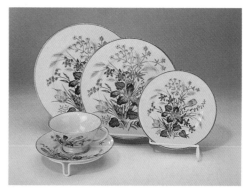

Mariposa five piece place setting. Dinner plate (10 7/8" d.); salad plate (8 1/4" d.); bread and butter plate (6 1/4 'd.); cup (2 1/4" d.) and saucer.

Martinique

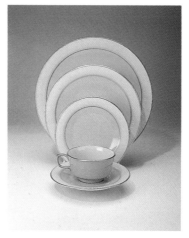

Martinique five piece place setting. Dinner plate (10 1/2" d.); salad plate (8 3/4" d.); bread and butter plate (6 1/4" d.); cup and saucer.

Maypole

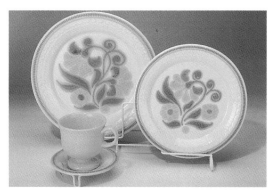

Maypole dinner plate (10 7/8" d.), salad plate (8 3/4" d.), cup (3 1/2" h.) and saucer.

Maytime

Maytime five piece place setting. Dinner plate (10 1/8" d.); salad plate; bread and butter plate; cup (2 1/4" d.) and saucer.

Meadow Rose

Meadow Rose serving platters.

Medallion

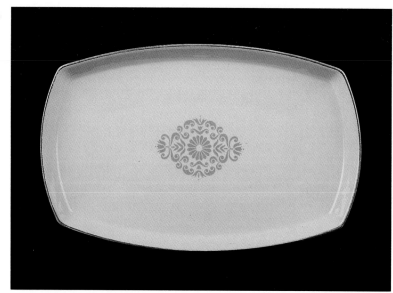

Medallion serving platter.

Melody

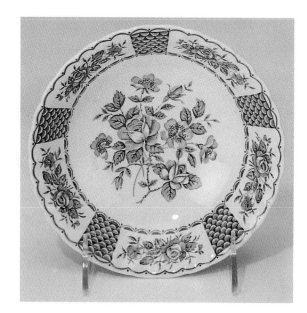

Melody cereal bowl (6 3/8" d.).

Melrose

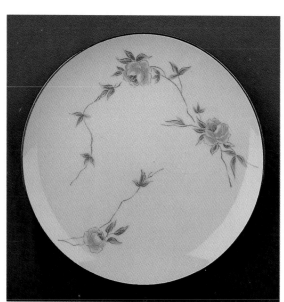

Melrose five piece place setting. Dinner plate (10 1/4" d.); salad plate (8 3/8" d.); bread and butter plate (6 1/2" d.); cup (2 3/4" h.) and saucer.

Menagerie,
Blue Border,
dinner plate.

Menagerie
(Blue Border)

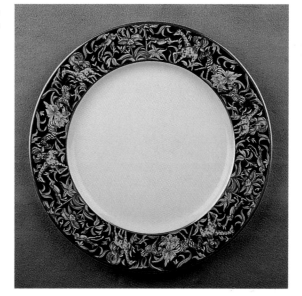

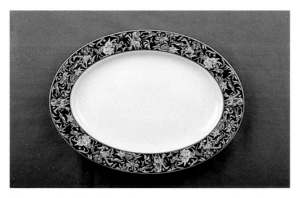

Menagerie, Black Border,
serving platter (14 1/8" d.).

Menagerie
(Black Border)

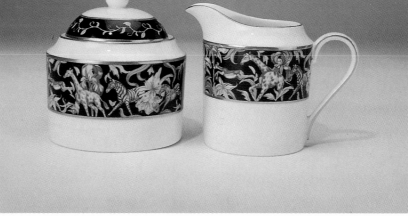

Menagerie, Black Border,
sugar bowl (4 1/4" h.) and
creamer (3 3/4" h.).

Merced

Merced shape undecorated gravy boat
with attached underplate.

Merry-Go-Round

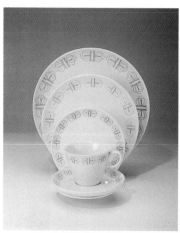

Merry-Go-Round five piece place setting. Dinner plate (10 1/4" d.); salad plate (8 1/4" d.); bread and butter plate (6 1/8" d.); cup (2 3/4" h.) and saucer.

Mesa (Pattern 1)

Mesa dinner plate, the first of two patterns to bear this name.

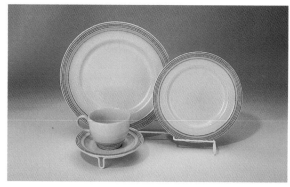

Mesa dinner plate (10 1/2"d.), salad plate (8 3/8" d.), cup (2 3/4" h.) and saucer.

Mesa (Pattern 2)

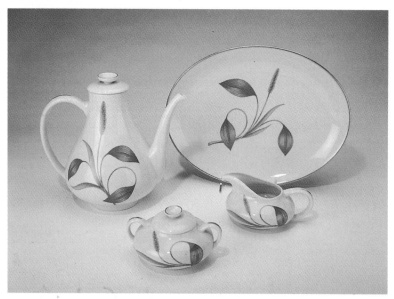

Mesa oval platter (12 1/2" d.), coffee pot (8 1/2" h.), sugar bowl, and creamer. The second of two patterns to bear this name.

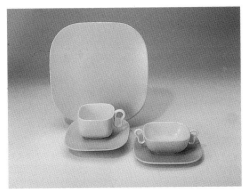

Metropolitan, Grey, dinner plate (9 7/8" d.), cup (2 3/8" h.) and saucer, and cream soup bowl and saucer.

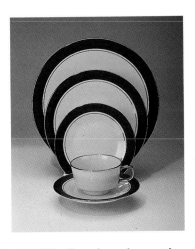

Midnight Mist five piece place setting. Dinner plate; salad plate (8 3/8" d.); bread and butter plate (6 1/4" d.); cup (2" d.) and saucer.

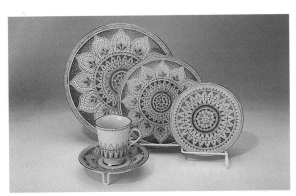

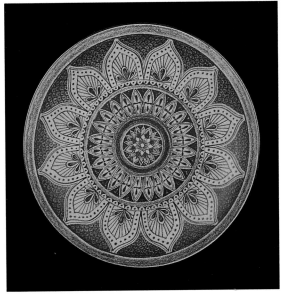

Minaret five piece place setting. Dinner plate (10 1/2" d.); salad plate (8 3/8" d.); bread and butter plate (6 3/8" h.); cup (3 1/2" h.) and saucer.

Mint Weave

Mint Weave salad plate.

Mirasol

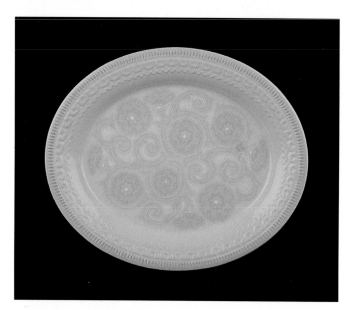

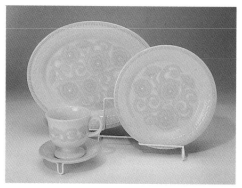

Mirasol oval serving platter (12" d.), salad plate (8 3/8" d.), cup (3 1/2" h.) and saucer.

Monaco

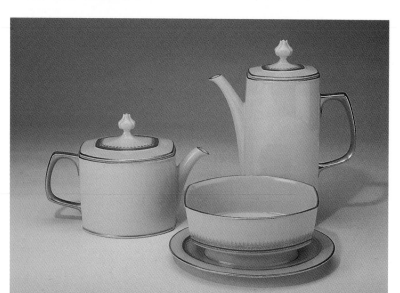

Monaco gravy dish (6 1/2" d.) with underplate (8" d.), teapot (6" h.), and coffee pot (9" h.).

Montecito five piece place setting. Dinner plate (10 3/4" d.); salad plate (8 3/8" d.); bread and butter plate (6 3/8" d.); cup (2 1/4" h.) and saucer.

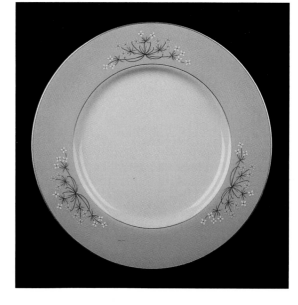

Montecito

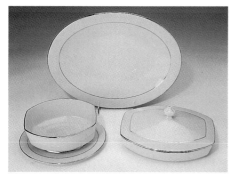

Moon Glow oval serving platter (13 1/8" d.), two piece gravy boat, oval covered vegetable dish.

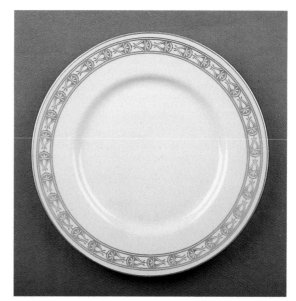

Monterey

Monterey dinner plate (10 5/8" d.).

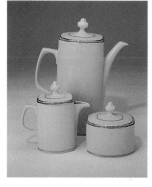

Moon Glow smooth border coffee pot, creamer, and sugar bowl.

Moon Glow

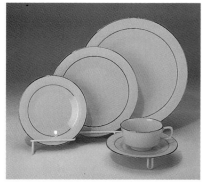

Moon Glow five piece place setting with a raised border design. Dinner plate, salad plate, bread and butter plate; cup (2 1/8" h.) and saucer.

93

Moondance

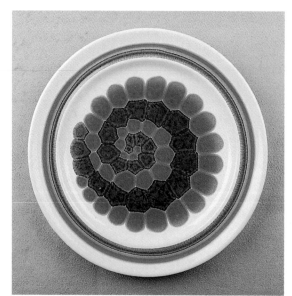

Moondance dinner plate (10 1/2" d.).

Moondance dinner plate (10 1/2" d.).

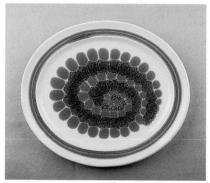

Moondance oval serving platter (13 1/2" d.).

Mountain Laurel

Moondance salad plate (8 1/2" d.), cup (3 1/8" h.) and saucer.

Mountain Laurel five piece place setting. Dinner plate (10 1/2" d.); salad plate (8 1/2" d.); bread and butter plate (6 1/2" d.); cup (2 1/4"h.) and saucer.

Nassau

Nassau dinner plate (10 1/4" d.).

Nature dinner plate (10 3/4" d.).

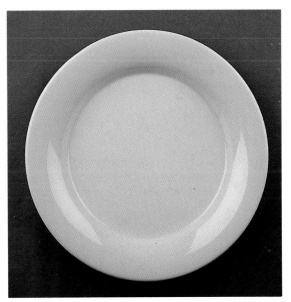

Nature

Newport five piece place setting. Dinner plate (10 3/8" d.); salad plate (8 1/8" d.); bread and butter plate (6 3/8" d.); cup (2 1/8" h.) and saucer.

Newport

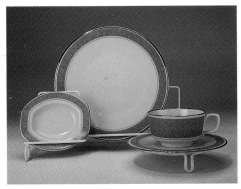

Nightingale salad plate (8 3/8" d.), small rectangular bowl (4 5/8" d.), cup (2 5/8" d.) and saucer.

Nightingale

Nightingale salad plate.

Nouvelle Ebony

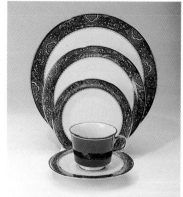

Nouvelle Ebony five piece place setting. Dinner plate (10 1/2" d.); salad plate (8 1/4" d.); bread and butter plate (6 1/4" d.); cup (2 5/8" h.) and saucer.

Nouvelle Ivory

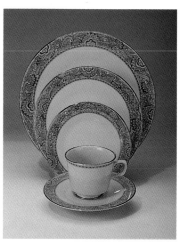

Nouvelle Ivory five piece place setting. Dinner plate (10 1/2" d.); salad plate (8 1/4" d.); bread and butter plate (6 1/4" d.); cup (2 3/4" d.) and saucer.

Nut Tree

Nut Tree round vegetable dish (9 3/8" d.).

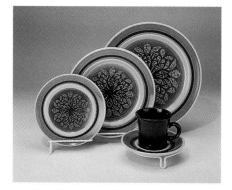

Nut Tree five piece plate setting. Dinner plate (10 5/8" d.); salad plate (8 1/2" d.); bread and butter plate (6 5/8" d.); cup (2 5/8" h.) and saucer.

Oasis

Oasis butter dish (8" x 5" base)
and jelly dish (7" x 6" d.).

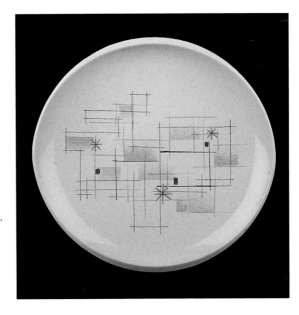

Oasis dinner plate.

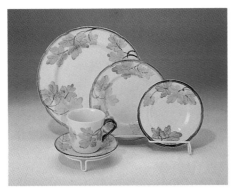

October

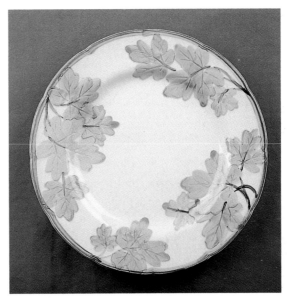

October five piece place
setting. Dinner plate (10
7/8" d.); salad plate (8"
d.); bread and butter
plate (6 1/2" d.); cup (2
3/8" h.) and saucer.

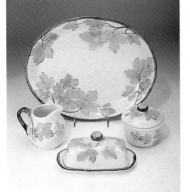

October oval serving platter, creamer,
butter dish, and sugar bowl.

Old Chelsea

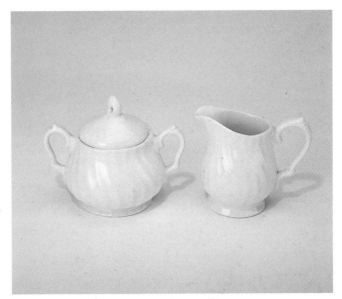

Old Chelsea sugar bowl and creamer.

Olympic

Olympic salad plate (8 1/4" d.).

Ondine

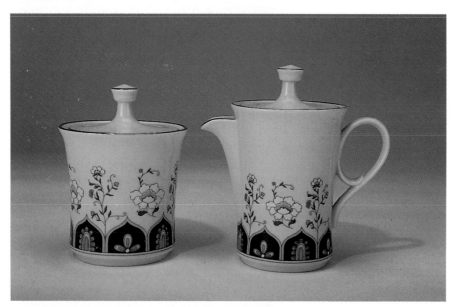

Ondine creamer (5 3/4" h.), and sugar bowl.

Orleans

Orleans dinner plate (10 1/8" d.).

Overture

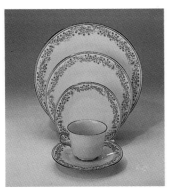

Overture five piece place setting. Dinner plate (10 1/2" d.); salad plate (8 1/4" d.); bread and butter plate (6 1/4" d.); cup (2 3/4" h.) and saucer.

Palo Alto

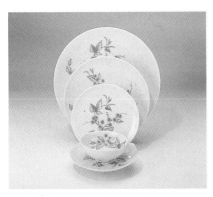

Palo Alto five piece place setting. Dinner plate (10 3/8" d.); salad plate (8 1/4" d.); bread and butter plate (6 1/4" d.); cup (1 5/8" h.) and saucer.

Palomar
(Blue)

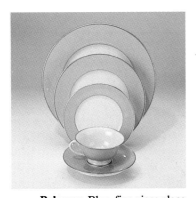

Palomar, Blue, five piece place setting. Dinner plate (10 5/8" d.); salad plate (8 3/8" d.); bread and butter plate (6 1/4" d.); cup (2 1/8" h.) and saucer.

Palomar
(Cameo
Pink)

Palomar, Cameo Pink, gravy boat with attached underplate.

Palomar
(Grey)

Palomar, Grey, five piece place setting. Dinner plate (10 5/8" d.); salad plate (8 1/4" d.); bread and butter plate (6 3/8" d.); cup (2 1/4" h.) and saucer.

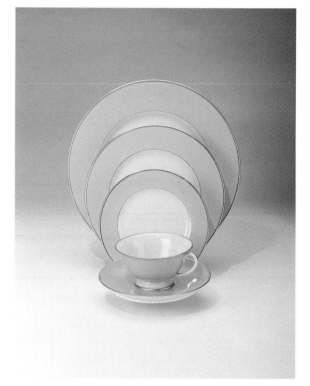

Palomar
(Grey,
Platinum)

Palomar, Grey, Platinum dinner plate (10 3/4" d.).

Palomar, Jade, salad plate (8 1/4" d.).

Palomar
(Jade)

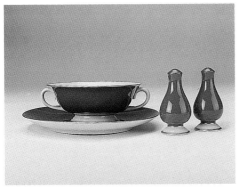

Palomar, Jade, cream soup and
saucer set, and salt & pepper set.

Palomar
(Jasper)

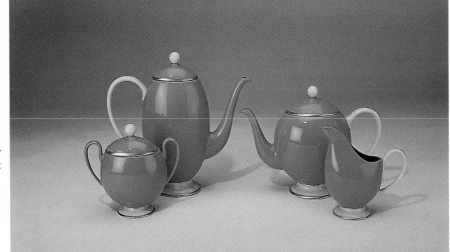

Palomar, Jasper, sugar
bowl, coffee pot, tea pot
and creamer.

Palomar
(Pink)

Palomar, Pink, five piece place setting. Dinner plate
(10 1/2" d.); salad plate (8 1/4"d.); bread and butter
plate (6 1/4" d.); cup (2 1/4"h.) and saucer.

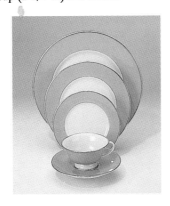

101

Patrician

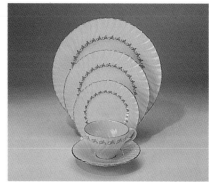

Patrician five piece place setting. Dinner plate (10 5/8" d.); salad plate (8 1/4" d.); bread and butter plate (6 1/8" d.); cup (2 3/4" h.) and saucer.

Paynsley

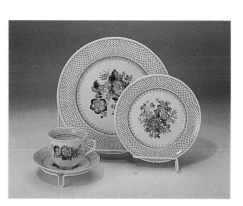

Paynsley dinner plate (10 1/2" d.), salad plate (8 1/4" d.), cup (2 3/4" h.) and saucer.

Peach Tree

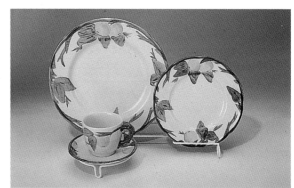

Peach Tree dinner plate (10 1/2" d.), salad plate (7 7/8" d.), cup (2 3/4" h.) and saucer.

Pebble Beach

Pebble Beach oval platter and gravy boat.

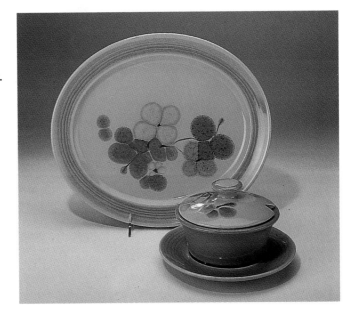

Pepper Poppy

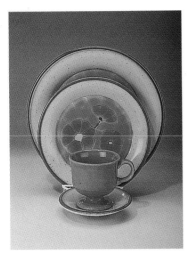

Pepper Poppy dinner plate (10 3/8" d.), salad plate (8 3/4" d.), cup (3 1/2" h.) and saucer.

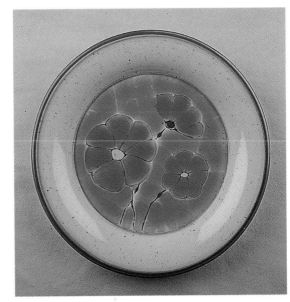

Petalpoint

Petalpoint dinner plate, marked Masterpiece China Made in U.S.A.

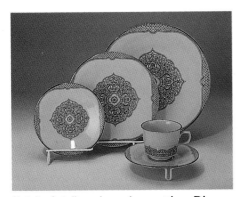

Petalpoint five piece place setting. Dinner plate (10 1/2" d.); salad plate (8 1/4" d.); bread and butter plate (6 1/4" d.); cup (2 3/4" h.) and saucer.

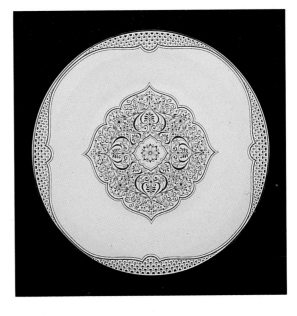

Pickwick

Pickwick dinner plate, Japanese Franciscan by TTK Japan.

Pickwick dinner plate (10 1/4" d.), coffee pot, and pitcher.

Picnic

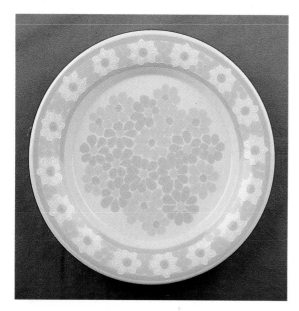

Picnic dinner plate (10 3/4" d.), salad plate (8 3/4" d.), and cup (3 1/2" h.).

Picnic round butter dish.

Picnic small underplate for salt & pepper set.

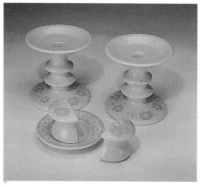

Picnic candlesticks (5 3/8" h.) and salt & pepper set.

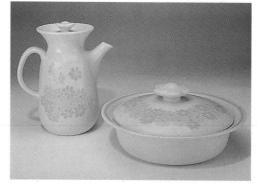

Picnic coffee pot and round vegetable bowl.

104

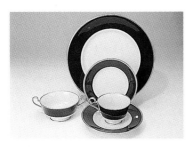

Piedmont, Cobalt Blue, dinner plate (10 1/2" d.), bread and butter plate (6 3/8" d.), cream soup bowl, cup (2 1/2" h.) and saucer.

Piedmont
(Cobalt Blue)

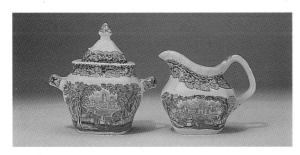

Pink Vista sugar bowl, and creamer, marked English Ironstone, Made in England.

Pink
Vista

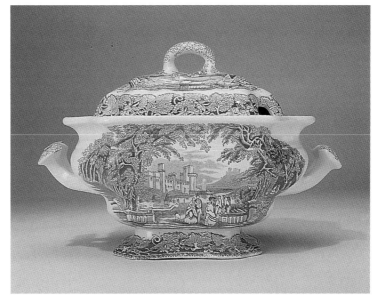

Pink Vista soup tureen (8 1/2" h. x 9 1/2 d.).

Pink-A-Dilly covered pot (8 1/2" d.) and gravy boat.

Pink-A-Dilly

Pink-A-Dilly dinner plate (10 1/4" d.).

105

Platina

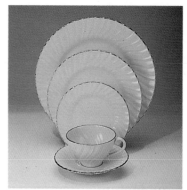

Platina five piece place setting. Dinner plate (10 3/4" d.); salad plate (8 1/4" d.); bread and butter plate (6 1/4" d.); cup (2 1/2" d.) and saucer.

Platina dinner plate.

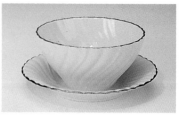

Platina gravy boat with attached underplate.

Platinum Band

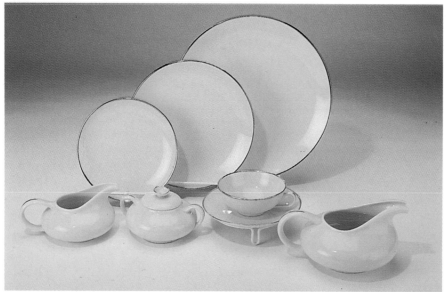

Platinum Band dinner plate (10 1/2" d.), salad plate (8 1/4" d.), bread and butter plate (6 1/4" d.), creamer, sugar bowl, cup and saucer, and gravy boat.

Pomegranite

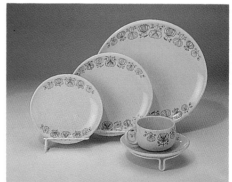

Pomegranite five piece place setting. Dinner plate (10 5/8" d.); salad plate (8 1/4" d.); bread and butter plate (6 5/8" d.); cup (2 5/8" h.) and saucer.

106

Poppy

Poppy bowl, 1950.

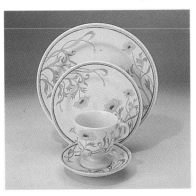

Poppy dinner plate (10 1/8" d.), bread and butter plate (6 1/4" d.), cup (2 1/4" h.) and saucer, and gravy boat with separate underplate.

Poppy
(Greenhouse Series)

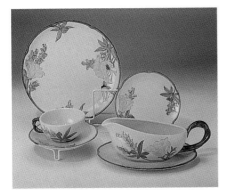

Poppy, Greenhouse Series, dinner plate (10 1/8" d.), salad plate (8" d.), cup (3 7/8" h.) and saucer.

Quadrille

Quadrille cup (2 3/4" h.) and saucer, Masterpiece China.

Radiance

Radiance dinner plate (10 3/8" d.), bread and butter plate (6 3/8" d.), cup (2 1/4" d.) and saucer.

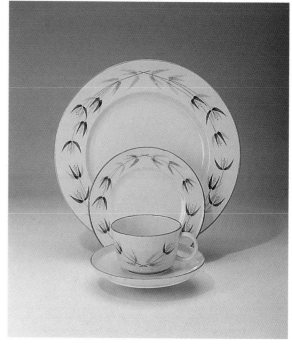

Rafiki
(Black Border)

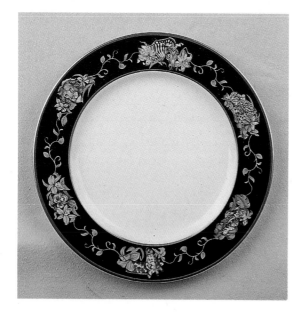

Rafiki, Black Border, dinner plate (10 3/4" d.).

Rafiki
(Blue Border)

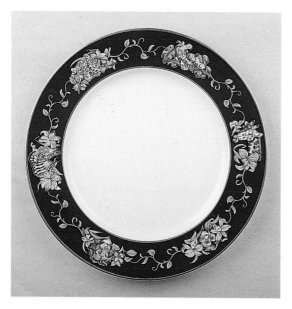

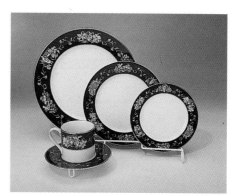

Rafiki, Blue Border, five piece place setting. Dinner plate (10 3/4" d.); salad plate (8 1/4" d.); bread and butter plate (6 1/2" d.); cup (2 3/4" h.) and saucer.

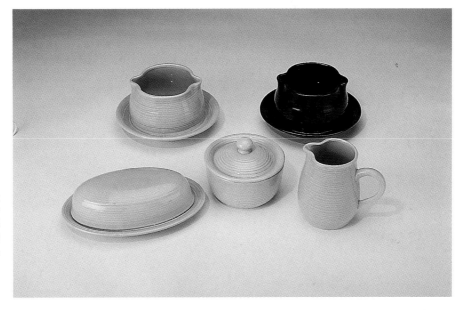

Reflections
(Black &
Grey)

Reflections, Black &
Grey, round vegetable
dish and a pitcher with
a wash basin.

Reflections
(Black &
Jade)

Reflections, Black
& Jade, two gravy
boats with attached
underplates, butter
dish, sugar bowl,
and creamer.

Reflections
(Burgundy)

Reflections, Burgundy, dinner plate (10 3/4" d.),
and cereal bowl (6 3/8" d.).

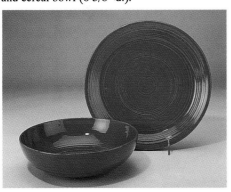

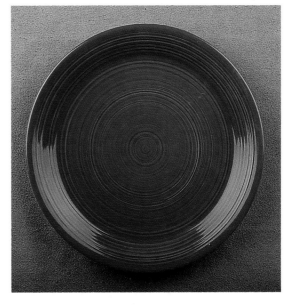

109

Reflections
(Lilac)

Reflections
(Peach,
far right)

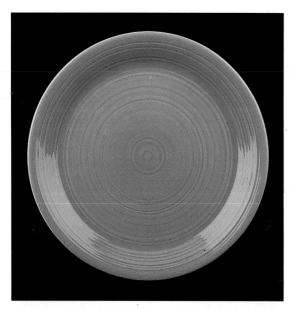

Reflections, Lilac, dinner plate (10 7/8" d.).

Reflections, Peach, dinner plate (10 7/8" d.).

Reflections
(Sand)

Reflections, Sand, dinner plate (10 7/8" d.), bread and butter plate (6 3/4" d.), cup (2 5/8" d.), and saucer.

Reflections
(Smoke Grey,
far right)

Reflections
(White)

Reflections, Smoke Grey, dinner plate (10 7/8" d.), salad plate (8 3/8" d.), cup (2 5/8" d.), and saucer.

Reflections, White, dinner plate (10 3/4" d.).

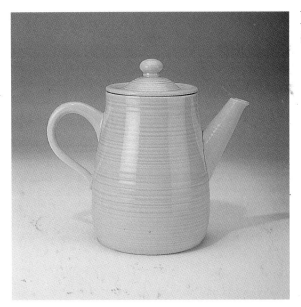

Reflections
(Yellow)

Reflections, Yellow, pitcher (8 3/4" h.).

Reflections
five piece
place set-
ting, made
in England.

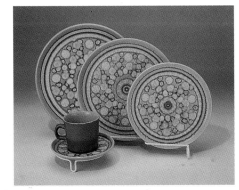

Reflections
(English)

Reflections dinner plate,
made in England.

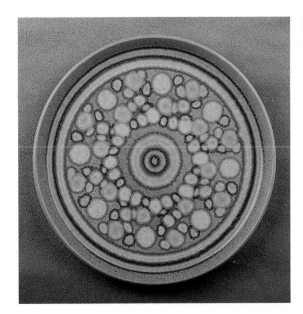

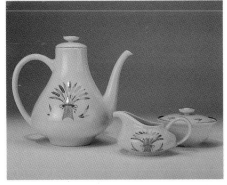

Regency coffee pot,
creamer, and sugar
bowl.

Regency

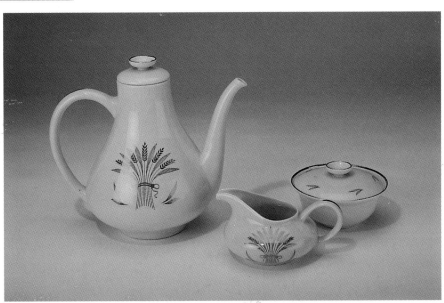

111

Renaissance
(Crown)

Renaissance, Crown, dinner plate.

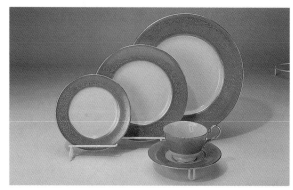

Renaissance, Crown, five piece place setting.

Renaissance
(Gold)

Renaissance Gold, dinner plate.

Renaissance
(Gold & Grey)

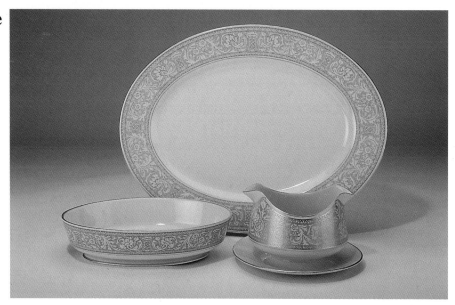

Renaissance, Gold and Grey, oval serving platter, oval vegetable bowl, and gravy boat with attached underplate.

Renaissance, Grey, dinner plate.

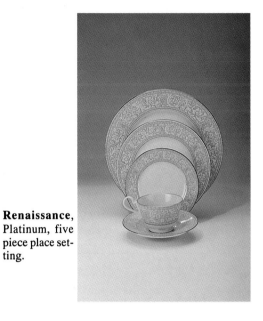

Renaissance, Platinum, five piece place setting.

Renaissance, Platinum, dinner plate.

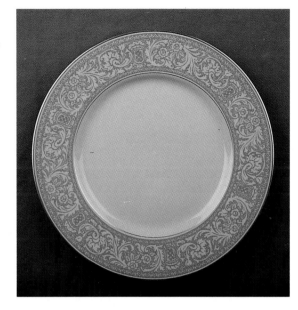

Renaissance (Grey)

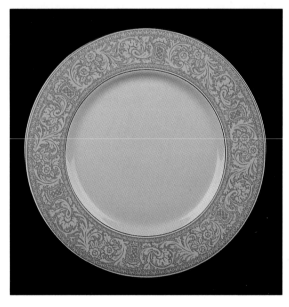

Renaissance (Platinum)

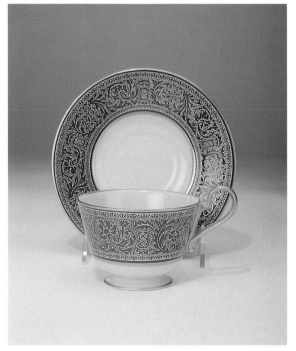

Royal Renaissance cup and saucer.

Royal Renaissance saucer.

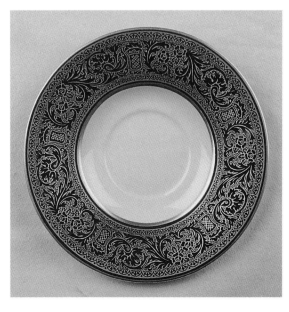

Royal Renaissance

Ridgewood

Ridgewood five piece place setting. Dinner plate (10 5/8" d.); salad plate (8 3/8" d.); bread and butter plate (6 3/8" d.); cup (2 1/4" h.) and saucer.

Rondelay

Rondelay five piece place setting. Dinner plate (10 3/4" d.); salad plate (8 3/8" d.); bread and butter plate (6 3/8" d.); cup (2 1/4" h.) and saucer.

Rosette

Rosette dinner plate.

Rossmore

Rossmore dinner plate.

Rossmore five piece place setting. Dinner plate (10 1/2" d.); salad plate (8 3/8" d.); bread and butter plate (6 1/4" d.); cup (2 1/8" h.) and saucer.

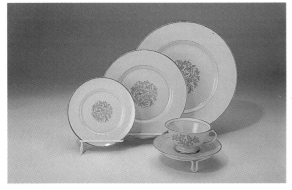

Rustic England

Rustic England dinner plate (10" d.).

Sandlewood

Sandlewood dinner plate (10 3/8" d.), salad plate (8 1/4" d.), cup (1 3/4" d.) and saucer.

Sea Sculptures (Conch Shell, Nautilus, Sand Dollar, Sea Urchin, Sand color)

Sea Sculptures Conch Shell, Nautilus, and Sea Urchin, Sand color, dinner and salad plates.

Sea Sculptures Conch Shell, Sand color, dinner plate (10 3/4" d.).

Sea Sculptures, Nautilus, Sand color, dinner plate (10 3/4" d.).

Sea Sculpture, Sand Dollar, Sand color, dinner plate (10 3/4" d.).

Sea Sculptures, Sea Urchin, Sand color, dinner plate (10 3/4" d.).

Sea Sculpture, Primary shape (no design), Sand color, dinner plate.

Sea Sculpture, Primary shape, Sand color, dinner plate (10 1/2" d.), luncheon plate (9 1/8" d.), cup (2 5/8" h.) and saucer.

Sea Sculpture, Fan Shell, White color, dinner plate.

Sea Sculpture (Fan Shell, Nautilus, Sea Urchin, White color)

Sea Sculpture, Sea Urchin, White color, dinner plate.

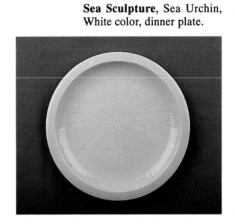

Sea Sculpture, Nautilus, White color, dinner plate.

Sea Sculpture, Fan Shell, Nautilus, and Sea Urchin, White color, dinner plates (10 3/4" d.); cup (2 5/8" h.) and saucer.

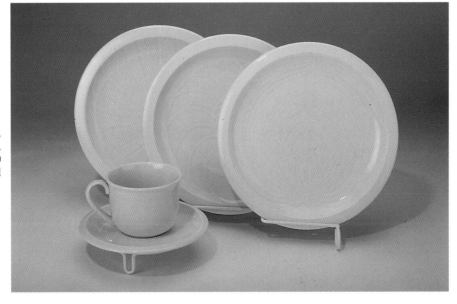

**Shady
Lane**

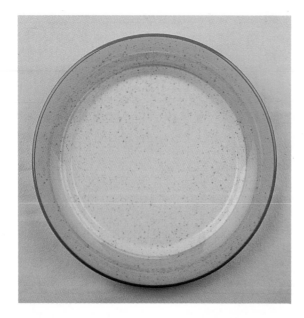

Shady Lane salad plate (8 7/8" d.).

Shalimar

Shalimar dinner plate (10 5/8" d.),
cup and saucer.

Shasta

Shasta five piece place setting, sugar bowl, creamer,
and gravy boat with an attached underplate. Dinner
plate (10 1/2" d.); salad plate (8 1/4" d.); bread and
butter plate (6 3/8" d.); cup (2" h.) and saucer; sugar
bowl (2 1/4" d.).

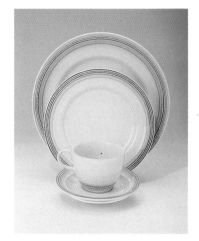

Sierra dinner plate, stoneware, (10 3/8" d.), bread and butter plate (6 1/4" d.), cup (1 5/8" d.) and saucer.

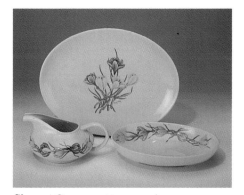

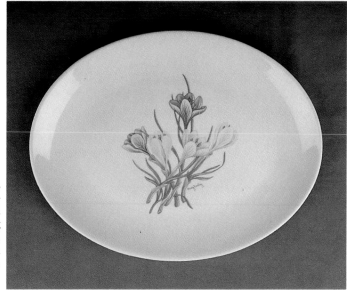

Sierra, Crocus pattern, oval serving platter (12 1/2" d.), gravy boat, and oval vegetable bowl (8 7/8" d.).

Sierra, Crocus pattern, oval serving platter, Franciscan Fine China.

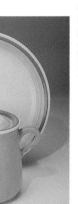

Sierra Sand dinner plate (10 5/8" d.), and cookie jar (5 3/4" h.).

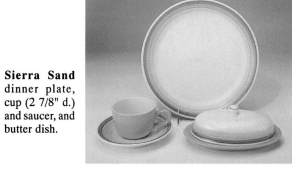

Sierra Sand dinner plate, cup (2 7/8" d.) and saucer, and butter dish.

Silver Lining

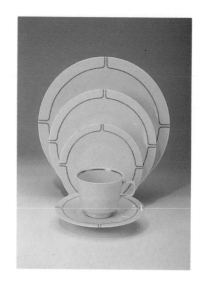

Silver Lining five piece place setting. Dinner plate (10 1/2" d.); salad plate (8 3/8" d.); bread and butter plate (6 1/4" d.); cup (2 3/4" h.) and saucer.

Silver Lining dinner plate, Franciscan Masterpiece.

Silver Mist

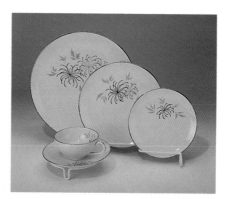

Silver Mist five piece place setting. Dinner plate (10 1/2" d.); salad plate (8 1/4" d.); bread and butter plate (6 3/8" d.); cup (2" h.) and saucer.

Silver Pine

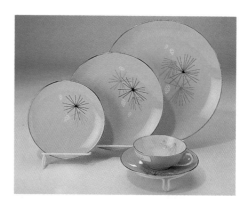

Silver Pine five piece place setting. Dinner plate (10 1/2" d.); salad plate (8 1/4" d.); bread and butter plate (6 3/8" d.); cup (1 3/4" h.) and saucer.

Simplicity five piece place setting. Dinner plate (10 1/2" d.); salad plate (8 3/8" d.); bread and butter plate (6 1/2" d.); cup (1 5/8" h.) and saucer.

Simplicity

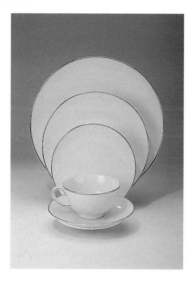

Snow Pine

Snow Pine five piece place setting. Dinner plate (10 5/8" d.); salad plate (8 1/4" d.); bread and butter plate (6 1/2" d.); cup (2 1/8" d.) and saucer.

Snowflakes

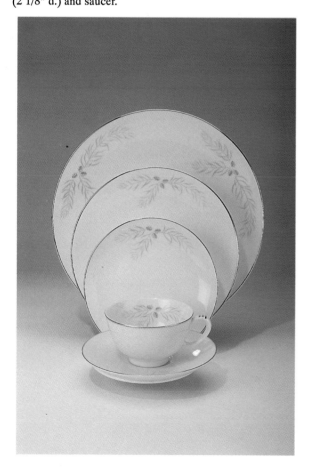

Somerset

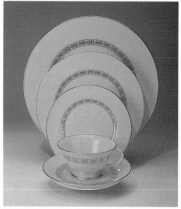

Somerset five piece place setting. Dinner plate (10 3/4" d.); salad plate (7 1/2" d.); bread and butter plate (6 3/8" d.); cup (2 1/4" d.) and saucer.

Sonora

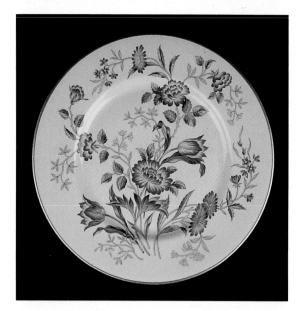

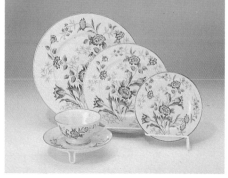

Sonora five piece place setting. Dinner plate (10 3/4" d.); salad plate (8 3/8" d.); bread and butter plate (6 3/8" d.); cup (2 1/8" h.) and saucer.

Spice cup (3" h.) and saucer, and bread and butter plate (6 1/2" d.).

Spice

Spice oval vegetable bowl.

Spice (left to right) pitcher (10 1/4" h.), sugar bowl, bread and butter plate (6 1/2" d.), creamer, and gravy boat (far right, back).

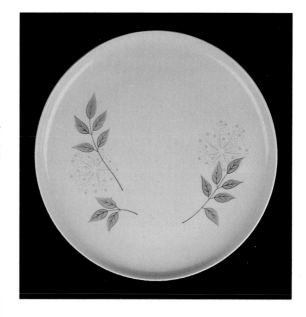

Spring Song dinner
plate (10 1/8" d.),
marked as Franciscan
Family China.

Spruce

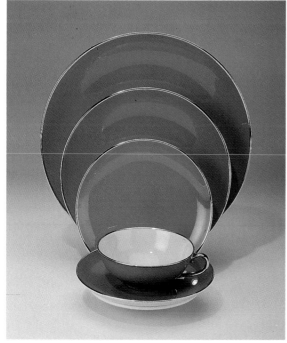

Spruce five piece place set-
ting. Dinner plate; salad
plate; bread and butter plate
(6 3/8" d.); cup (1 3/4" h.)
and saucer.

St. Louis

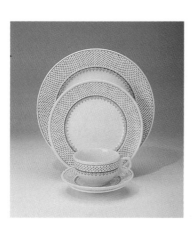

St. Louis dinner plate (10 1/8" d.),
salad plate (7 7/8" d.), cup (2 1/8" h.)
and saucer.

St. Moritz

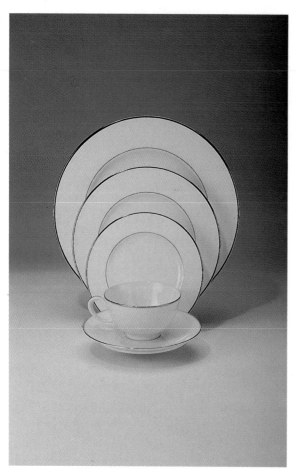

St. Moritz oval serving platter, creamer, and sugar bowl.

St. Moritz five piece place setting, Cosmopolitan China. Dinner plate (10 5/8" d.); salad plate (8 1/4" d.); bread and butter plate (6 3/8" d.); cup (2 1/8" h.) and saucer.

Starburst

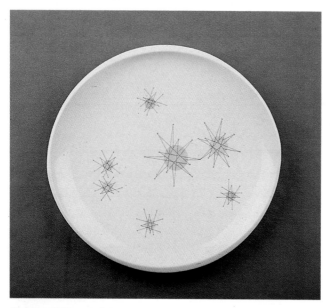

Starburst dinner plate.

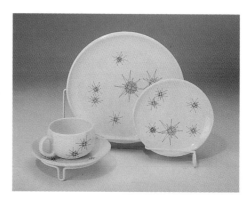

Starburst dinner plate, bread and butter plate (6 1/2" d.), cup (2 1/4" d.) and saucer.

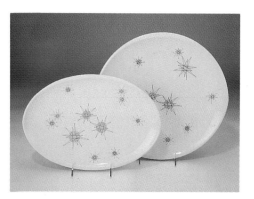

Starburst

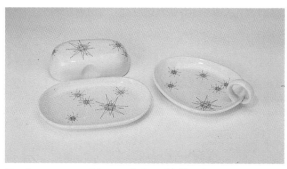

Starburst oval serving platter (15 1/8 d.) and round serving platter (13 1/8" d.).

Starburst covered butter dish and jelly plate.

Starry Night bread and butter plate.

Starry Night

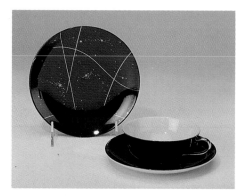

Starry Night dinner plate, cup (1 5/8" h.) and saucer.

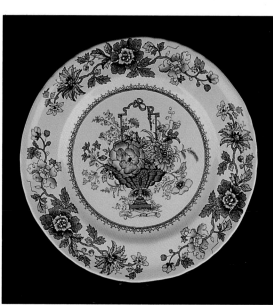

Strathmore

Strathmore dinner plate (10 1/2" d.).

Strawberry Fair

Strawberry Fair dinner plate (10 3/4" d.) was introduced in 1979. The differences between Strawberry Fair and Strawberry Time are in the flowers and the background color. Strawberry Fair has pink petaled flowers and a cream colored background; Strawberry Time has white petaled flowers and a green colored background.

Strawberry Time

Strawberry Time saucer.

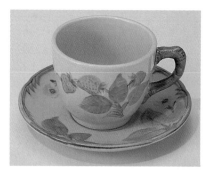

Strawberry Time cup and saucer, 1983.

Sun Song

Sun Song dinner plate.

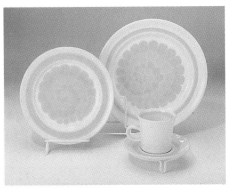

Sundance dinner plate (10 1/2" d.), salad plate (8 1/2 d.), cup (3 1/8" h.) and saucer.

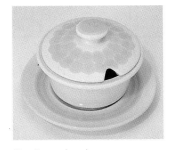

Sundance chip & dip set.

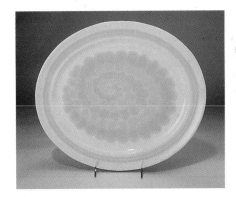

Sundance oval serving platter.

Sundance jam jar, the hole in the lid accommodates a spoon.

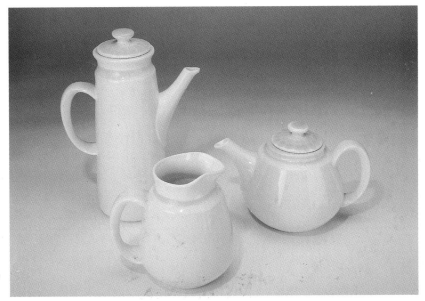

Sundance coffee pot, creamer, and teapot.

Sunset

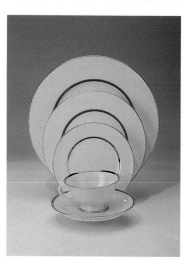

Sunset five piece place setting. Dinner plate (10 1/2" d.); salad plate (8 1/4" d.); bread and butter plate (6 3/8" d.); cup (2 1/4" h.) and saucer.

Sweet Pea

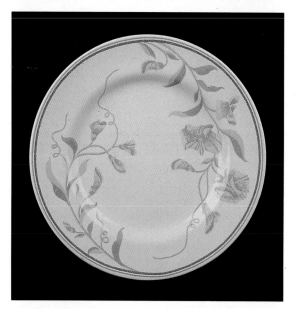

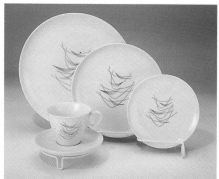

Sweet Pea dinner plate (10 3/4" d.), salad plate (8" d.), goblet (6 1/2" h.), cup (2 3/4" h.) and saucer.

Swing Time

Swing Time was produced in Japan on Whitestone Ware. Swing Time, five piece place setting. Dinner plate (10 1/4" d.); salad plate (8 1/4" d.); bread and butter plate (6 1/8" d.); cup (2 3/4" h.) and saucer.

Sycamore dinner plate (10 1/2" d.) and a gravy boat with an attached underplate (5" w. to lips, 3 3/4" h.).

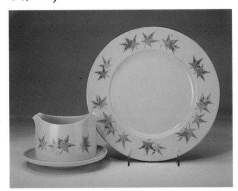

Sycamore

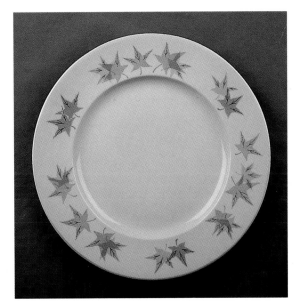

Sycamore platter (13 1/8" w.).

Tahiti

Tahiti five piece place setting. Dinner plate (10 3/8" d.); salad plate (8 3/8" d.); bread and butter plate (6 3/8" d.); cup (2 1/4" h.) and saucer.

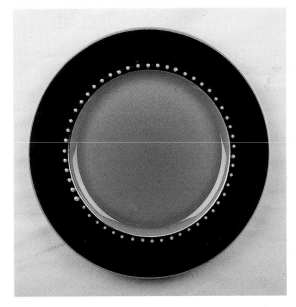

Tahoe

Tahoe bread and butter plate (6 3/8" d.) and gravy boat.

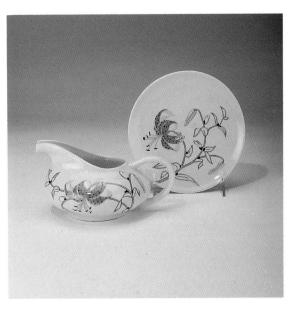

Talisman

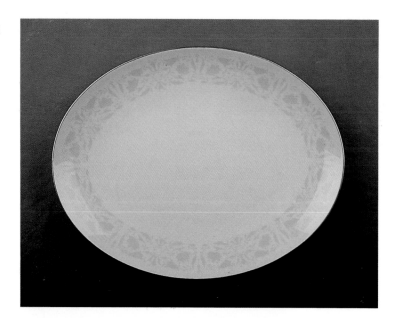

Talisman platter (15" l.).

Tangier

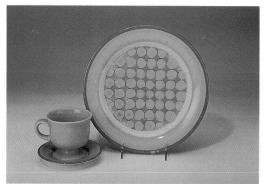

Tangier dinner plate (10 1/2" d.), cup (3 1/2" h.) and saucer.

Tapestry

Tapestry dinner plate (10 5/8" d.), bread and butter plate (6 3/8" d.), cup (2 3/8" h.) and saucer.

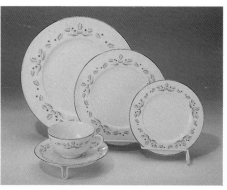

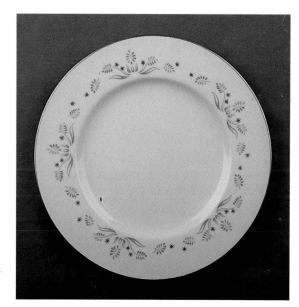

Tara

Tara five piece place setting. Dinner plate (10 5/8" d.); salad plate (8 3/8" d.); bread and butter plate (6 3/8" d.); cup (2 1/8" h.) and saucer.

Tara dinner plate, marked Franciscan Cosmopolitan China.

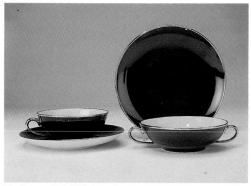

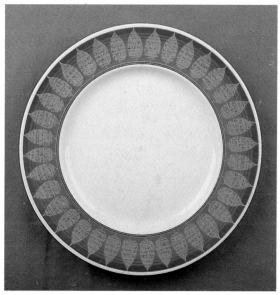

Teak

Teak cup (1 3/4" h.) and saucer and cream soup and saucer set.

Teak saucer for a cream soup and saucer set (7" d.).

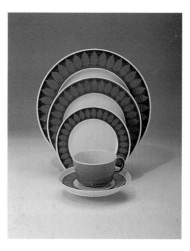

Terra Cotta

Terra Cotta five piece place setting. Bread and butter plate (6 3/8" d.); cup (2 1/8" h.) and saucer.

Tiempo
(Apricot)

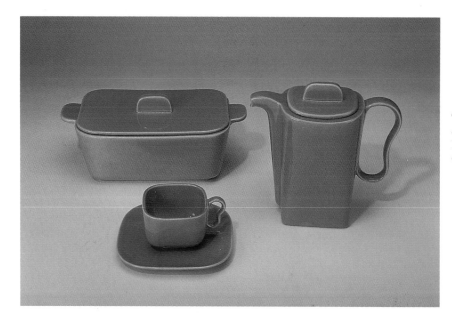

Tiempo, Apricot, rectangular covered vegetable dish (upper left), coffee pot (7 1/4" h., right), cup (2 3/8" h.) and saucer.

Tiempo
(Grey)

Tiempo, Grey, dinner plate (9 3/4" d., upper left), pitcher (7 1/4" h.), tumbler (5" h.), and square vegetable dish (12 7/8" d.).

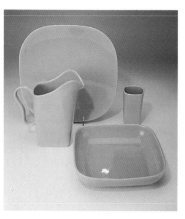

Tiempo, Lime Green, cereal bowl (top), covered butter dish (left), sugar bowl (right), and fruit bowl (4 1/2" d., bottom).

Tiempo
(Lime
Green)

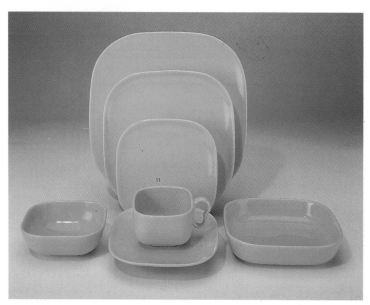

Tiempo, Lime Green, five piece place setting, fruit bowl (4 1/2" d., left), and cereal bowl (right). Dinner plate (9 3/4" d.); salad plate (8 1/8" d.); bread and butter plate (6" d.); cup (2 1/4" h.) and saucer.

132

Tiempo (Olive Green)

Tiempo, Olive Green, dinner plate (9 3/4" d.).

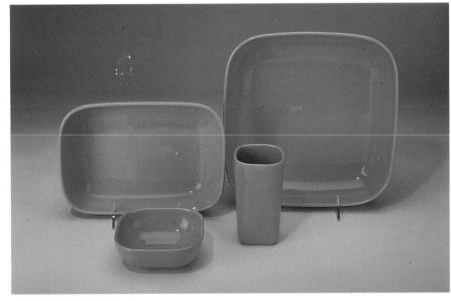

Tiempo (Tan)

Tiempo, Tan, oval vegetable dish (9 1/4" d., left back), fruit bowl (4 1/2" d., left front), square vegetable dish (10 1/8" d., right back), and a tumbler (5" h.).

Toffee dinner plate (10 3/4" d.), salad plate (8 1/4" d.), cup (2 5/8" h.) and saucer.

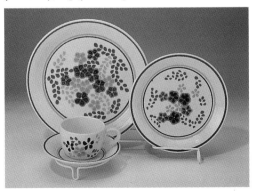

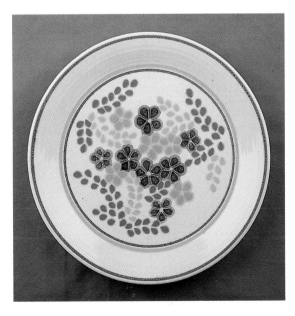

Toffee

Toffee dinner plate, marked The California Craftsmen Since 1875 by Interpace.

Tonquin
(Brown)

Tonquin, brown transfer print, bread and butter plate featuring a chinoiserie pattern.

Tonquin
(Pink)

Tonquin cup (2 5/8" h.) and saucer and bread and butter plate (6 3/4" d.).

Tonquin, pink transfer printed chinoiserie pattern, dinner plate (9 3/4" d.).

Topaz

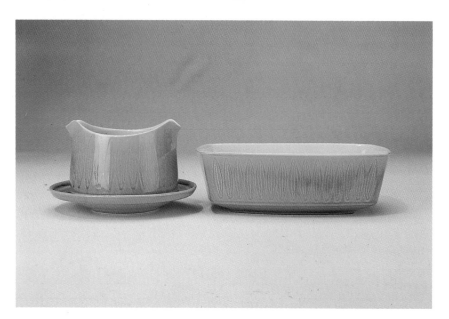

Topaz gravy boat with attached underplate and an oval vegetable dish (8 1/4" l.). These are marked Franciscan Discovery.

134

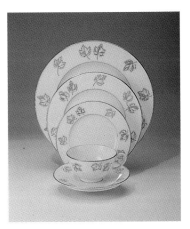

Trianon five piece place setting. Dinner plate (10 3/4" d.); salad plate (8 3/8" d.); bread and butter plate (6 3/8" d.); cup (2 1/8" h.) and saucer.

Trianon

Trianon dinner plate, marked Cosmopolitan China.

Trio

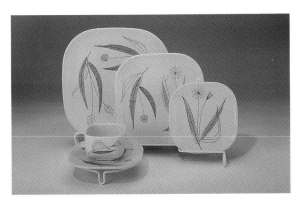

Trio five piece place setting. Dinner plate (9 3/4" d.); salad plate (8" d.); bread and butter plate (6" d.); cup (2 1/4" h.) and saucer.

Tulip

Tulip embossed and hand-painted platter (14 1/4" l.).

Tuliptime

Tuliptime five piece place setting. Dinner plate (10 3/4" d.); salad plate (8 3/8" d.); bread and butter plate (6 3/4" d.); cup (2 1/2" h.) and saucer.

Tuliptime pepper mill and salt shaker.

Twice Nice

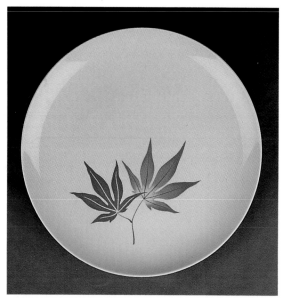

Twice Nice dinner plate (10 1/4" d.), bread and butter plate (6 1/4" d.), cup (2 3/4" h.) and saucer.

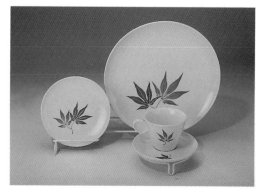

Twilight

Twilight salad plate (8 1/4" d.), fruit bowl (4 7/8" d.), cup (1 3/4" h.) and saucer.

136

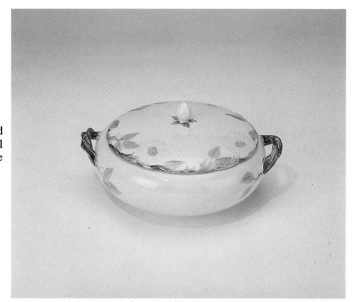

Twilight Rose

Twilight Rose round covered vegetable dish, the final variation of the Desert Rose pattern.

Valencia five piece place setting. Dinner plate (10 3/8" d.); salad plate (8 1/8" d.); bread and butter plate (6 3/8" d.); cup (2 1/8" h.) and saucer.

Valencia

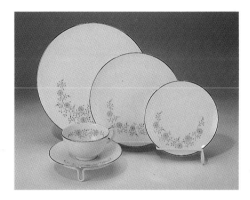

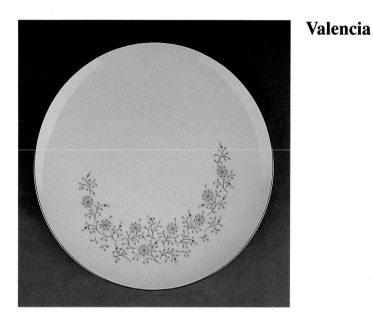

Valencia dinner plate, marked Franciscan Cosmopolitan China.

Westwood

Westwood sugar bowl (4" h.), coffee pot (8" h.), teapot (5 1/4" h.), and creamer (3" h.).

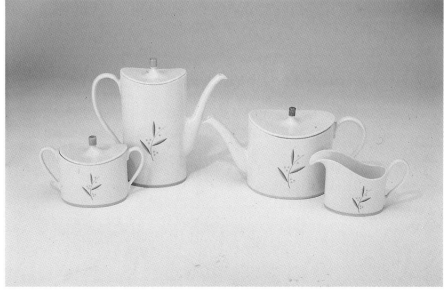

137

Wheat
(Golden
Brown)

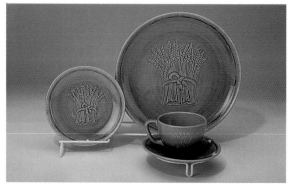

Wheat, Golden Brown, dinner plate (10 1/2" d.), bread and butter plate (6 1/2" d.), cup (2 5/8" h.) and saucer.

Wheat
(Green)

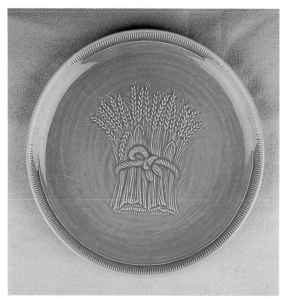

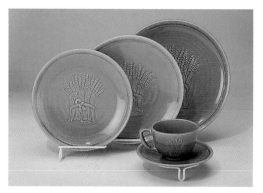

Wheat, Green, dinner plate (10 1/2" d.), luncheon plate (9 3/8" d.), salad plate (8 3/4" d.), cup (2 5/8" h.) and saucer.

Wheat
(Light
Gold)

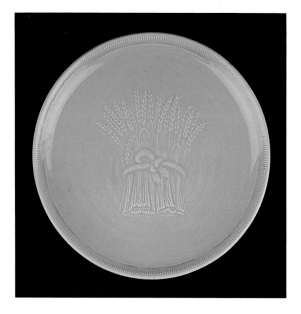

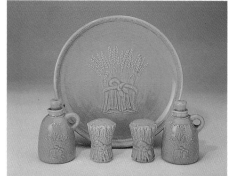

Wheat, Light Gold, dinner plate (10 1/2" d.), oil and vinegar cruets shaped like jugs, and salt and pepper shakers shaped as harvested wheat.

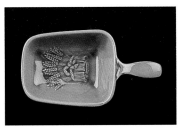

Wheat, Light Gold, scoop.

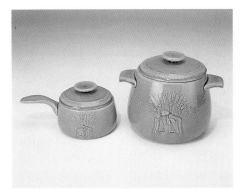

Wheat (Light Gold)

Wheat, Light Gold, individual serving covered dish with a handle and a bean pot.

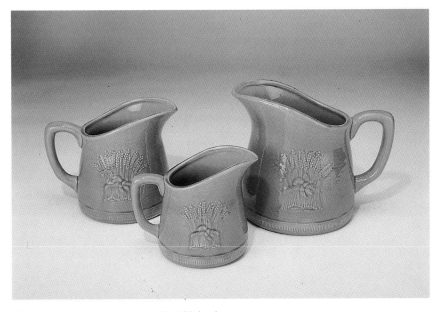

Wheat, Light Gold, creamer (3 1/8" h., in front) and two pitchers (4 3/4" h. & 7" h.).

Wheat, Light Gold, covered butter dish.

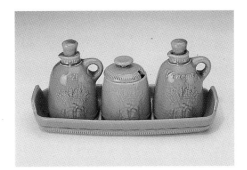

Wheat, Light Gold, condiment set. Oil and vinegar cruets and a small covered mustard pot rest upon a small tray.

Wheat, Light Gold, chip and dip set.

Whirl-A-Gig

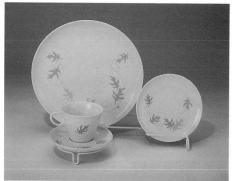

Whirl-A-Gig dinner plate (10 1/4" d.), bread and butter plate (6 1/8" d.), cup (2 3/4" h.) and saucer.

Wild Flower

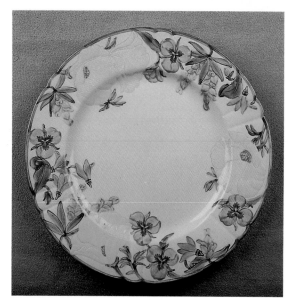

Wild Flower dinner plate, 1940

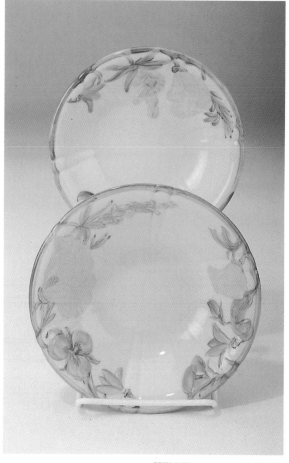

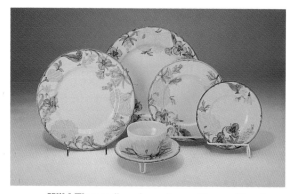

Wild Flower five piece place setting and luncheon plate (far left). Dinner plate (10 1/2" d.); luncheon plate (9 1/2" d.); salad plate (8 1/2" d.); bread and butter plate (6 3/8" d.); cup (2 1/2" h.) and saucer.

Wild Flower cereal (6" d.) and fruit (5 1/2" d.) bowls.

Wild Flower cereal (6" d.) and fruit (5 1/2" d.) bowls.

Wild Flower 1 1/2 quart covered casserole (3 1/2" h.).

Wild Flower sugar bowl and jam jar. The hole in lid of the jam jar accommodates the spoon.

Wild Flower chop plate (12" d.) and cereal bowl.

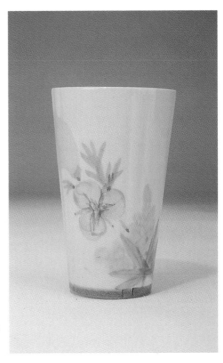

Wild Flower 10 ounce tumbler (5 1/2" h.).

Willow

Willow, light green with platinum trim, dinner plate, marked Franciscan China.

Willow five piece place setting. Dinner plate (10 1/2" d.); salad plate (8 1/4" d.); bread and butter plate (6 3/8" d.); cup (1 5/8" h.) and saucer.

Willow Bouquet tea set: creamer, sugar bowl, and teapot.

Windemere

Windemere dinner plate. Franciscan produced in Japan in the mid-1980s.

Windemere dinner plate (10 3/4" d.), creamer, and sugar bowl.

Winsome dinner plate (10 1/8" d.), bread and butter plate (6" d.), cup (2 1/4" h.) and saucer.

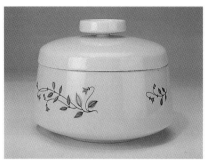

Winsome covered casserole (6 1/4" d.).

Winter Bouquet five piece place setting. Dinner plate (10 1/2" d.); salad plate (8 1/4" d.); bread and butter plate (6 3/8" d.); cup (1 3/4" h.) and saucer; and an additional, slightly larger cup (2 1/4" h.).

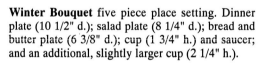

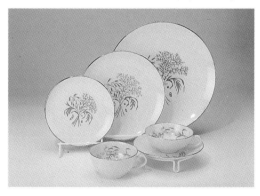

Woodlore bread tray (18" l.).

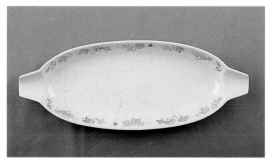

Woodlore dinner plate.

143

Woodside

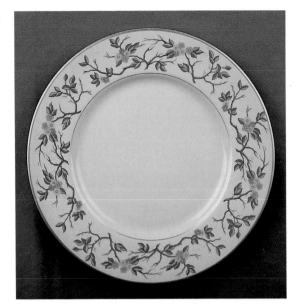

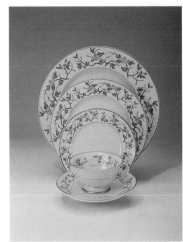

Woodside five piece place setting. Dinner plate (10 1/2" d.); salad plate (8 3/8" d.); bread and butter plate (6 3/8" d.); cup (2 1/4" h.) and saucer.

Zanzibar

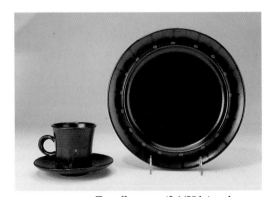

Zanzibar cup (3 1/8" h.) and saucer and dinner plate (10 3/8" d.).

Zanzibar dinner plate, the pattern is a very faint transfer print around the rim.

Zinnia

Zinnia dinner plate (10 1/2" d.) and salad plate (8 3/8" d.).

Zinnia dinner plate.

Endnotes

Introduction

1. Gaylen Drucker, "Collectibles: Franciscan Ware."*Bon Appetit,* Vol. 38(1), January 1993, p. 18.
2. Delleen Enge, *Franciscan. Embossed Hand Painted.* (Ojai, CA: Ojai Printing and Publishing Company, 1992), p. 11.

Chapter 1. History

1. Gladding, McBean, and Chambers had come west from Chicago, Illinois. Placer County was so named for the gold nuggets and dust dubbed "gold placers" by California prospectors of the late 184 0s. Drucker, "Collectibles: Franciscan Ware." p. 18.
2. This formula had been purchased by Gladding, McBean and Company from Willis Prouty, T.C. Prouty's son. Harvey Duke, *The Official Price Guide to Pottery and Porcelain.* (New York: House of Collectibles, 1995), p. 203; Delleen Enge, *Franciscan Ware. An Illustrated Price Guide.* (Paducah, KY: Collector Books, 1981), pp. 7-8.
3. The Malinite U.S. Patent number is 320539. Enge, *Franciscan,* p. 10; Jo Cunningham, *The Best of Collectible Dinnerware.* (Atglen, PA: Schiffer Publishing, 1995), p. 14.
4. Enge, *Franciscan,* p. 10; Hannah, *Ceramics,* p.101.
5. Enge, *Franciscan,* p. 10; Elisabeth Cameron, *Encyclopedia of Pottery and Porcelain. 1800-1960.* (New York: Facts on File Publications, 1986), pp. 140-141.
6. Enge, *Franciscan,* p. 10; Jo Cunningham, *The Collector's Encyclopedia of American Dinner ware.* (Peducah, KY: Collector Books, 1982), p. 37.
7. Enge, *Franciscan,* p. 10.
8. ibid, p. 11.
9. ibid, p. 11.
10. ibid, p. 11.
11. ibid, p. 11; Duke, *The Official Price Guide to Pottery and Porcelain,* p. 203.
12. Enge, *Franciscan,* p. 11; personal conversation with Jaime L. Robinson, March 25, 1996.
13. Frances Hannah, *Ceramics. Twentieth-Century Design.* (New York: E.P. Dutton, 1986), p. 102; Lois Lehner, *Lehner's Encyclopedia of U.S. Marks on Pottery, Porcelain, and Clay.* (Paducah, KY: Collector Books, 1988), p. 221.

Chapter 2. Franciscan Ware, Materials and Patterns

1. Franciscan China is renamed Franciscan Fine China in 1947. Lehner, *Lehner's Encyclopedia of U.S. Marks on Pottery, Porcelain, and Clay,* p. 165.
2. Leslie Piña, *Pottery. Modern Wares. 1920-1960.* (Atglen, PA: Schiffer Publishing, 1994) p. 6.
3. Enge, *Franciscan,* p. 10.
4. During this period many other American potters discovered that they could no longer profitably produce labor-intensive dining services and closed their American plants' doors as well. Enge, *Franciscan,* p. 11.
5. Duke, *The Official Price Guide to Pottery and Porcelain,* p. 952.
6. William C. Ketchum, Jr., *Pottery & Porcelain.* (New York: Collector Books, 1983), p.168.
7. Jeffrey B. Snyder, *A Pocket Guide to Flow Blue.* (Atglen, PA: Schiffer Publishing, 1995), p. 29.
8. Duke, *The Official Price Guide to Pottery and Porcelain,* pp. 957, 959.
9. Enge, *Franciscan,* p. 68.
10. ibid, p. 67.
11. Hannah, *Ceramics,* p. 101.
12. Enge, *Franciscan Ware,* pp. 11-12.
13. Duke, *The Official Price Guide to Pottery and Porcelain,* p. 208.
14. ibid, p. 210.
15. ibid, p. 212.
16. Enge, *Franciscan,* p. 12.
17. ibid, p. 12.
18. Duke, *The Official Price Guide to Pottery and Porcelain,* p. 223.
19. Enge, *Franciscan,* pp. 13-14.
20. ibid, p. 13.
21. Duke, *The Official Price Guide to Pottery and Porcelain,* pp. 220-221.
22. ibid, p. 217.
23. ibid, p. 217.

Chapter 3. Manufacturer's Marks

1. Duke, *The Official Price Guide to Pottery and Pocelain,* p. 19.
2. ibid, p. 18.
3. ibid, pp. 205-206.
4. ibid, pp. 205-206.
5. ibid, pp. 205-206.
6. Lehner, *Lehner's Encyclopedia of U.S. Marks on Pottery, Porcelain, and Clay,* p. 169. Many of the dates in the price guide are based on data from this source from pp. 169-172.
7. ibid, p. 169.
8. ibid, p. 169.

Bibliography

Cameron, Elisabeth. *Encyclopedia of Pottery and Porcelain. 1800-1960.* New York: Facts on File Publications, 1986.

Cunningham, Jo. *The Best of Collectible Dinnerware.* Atglen, Pennsylvania: Schiffer Publishing, 1995.

_____. *The Collector's Encyclopedia of American Dinnerware.* Peducah, Kentucky: Collector Books, 1982.

Drucker, Gaylen. "Collectibles: Franciscan Ware." *Bon Appetit*, January 1993, Vol. 38(1), p. 18.

Duke, Harvey. *The Official Price Guide to Pottery and Porcelain.* 8th Edition. New York: House of Collectibles, 1995.

Enge, Delleen. *Franciscan. Embossed Hand Painted.* Ojai, California: Ojai Printing and Publishing Company, 1992.

_____. *Franciscan Ware. An Illustrated Price Guide.* Paducah, Kentucky: Collector Books, 1981.

Hannah, Frances. *Ceramics. Twentieth-Century Design.* New York: E.P. Dutton, 1986.

Ketchum, William C., Jr. *Pottery & Porcelain. The Knopf Collectors' Guides to American Antiques.* New York: Alfred A. Knopf, 1983.

Lehner, Lois. *Lehner's Encyclopedia of U.S. Marks on Pottery, Porcelain, and Clay.* Paducah, Kentucky: Collector Books, 1988.

Lewis, Herschell & Margo. *Everybody's guide to plate collecting.* Chicago, Illinois: Bonus Books, 1988.

Piña, Leslie. *Pottery. Modern Wares. 1920-1960.* Atglen, Pennsylvania: Schiffer Publishing, 1994.

Replacements, Ltd. *Suppliers' Index. May 1 - July 31, 1995.* Greensboro, North Carolina, 1995.

Savage, George and Harold Newman. *An Illustrated Dictionary of Ceramics.* London: Thames and Hudson, Ltd., 1985 revised.

Snyder, Jeffrey B. *A Pocket Guide to Flow Blue.* Atglen, Pennsylvania: Schiffer Publishing, 1995.

Index

Franciscan Patterns, Pieces, and Price Guide

Values vary immensely according to the condition of the piece, the location of the market, and the overall quality of the design and manufacture. Condition is always of paramount importance in assigning a value. Prices in the Midwest differ from those in the West or East, and those at specialty antique shows will vary from those at general shows. And, of course, being at the right place at the right time can make all the difference.

All of these factors make it impossible to create an absolutely accurate price list, but a general guide can be offered. The values reflect what one might realistically expect to pay at retail or auction for pieces in fine condition.

Pattern names for Franciscan ceramics appear on the left. Values presented are estimated price ranges in United States dollars. The X marks indicate known forms (other than those for which values are given) produced in each pattern; vessel forms without X's in certain patterns indicate that it is not known at present whether those particular forms were produced in those patterns. The dates at the far right indicate the first year of production for each pattern for which that date is currently known.

I wish you the best of luck in building your Franciscan collection.

Pattern Name	Dinner Plate	Cup & Saucer	Salad Plate	Bread & Butter Plate	Luncheon Plate	Creamer	Sugar Bowl	Oval Vegetable	Round Vegetable	Platters 10"-18"	Five Piece Place Setting	Fruit Bowl	Cereal Bowl	Soup Bowl	Cream Soup & Saucer	Gravy Boat	Butter Dish	Salt & Pepper	Teapot	Coffee Pot	Covered Vegetable	Demitasse	Date First Produced
Acacia	32-40	45-55	22-26	16-20	X	X	X	X	X	X	X	X	X	X	X	X	X	X	X	X	X	X	1958
Alpine Meadow	18-22	23-29	10-12	7-9	X	X	X	X	X	X	X	X	X	X	X	X	X	X	X	X	X	X	
Amapola	15-19	20-24	9-11	5-7	X	X	X	X	X	X	X	X	X			X	X	X	X	X			1973
Angelica	19-23	25-31	11-13	7-9	X	X	X	X	X	X	X	X	X	X	X	X	X	X	X	X	X		
Antigua	14-18	19-23	8-10	4-6	X	X	X	X	X	X	X	X		X	X	X	X	X	X	X	X		1966
Antique Green	35-43	40-50	23-29	17-21	X	X	X	X	X	X	X		X			X	X	X	X	X	X	X	1966
Apollo	28-34	38-46	17-21	13-15	X	X	X	X	X	X	X	X				X	X	X	X	X	X		
Apple, American	18-22	11-13	13-15	6-8	X	X	X	X	X	X	X					X	X	X	X	X	X	X	1940
Apple, English	13-15	13-15	9-11	8-10	X	X	X	X	X	X	X	X	X	X	X	X	X	X	X	X	X	X	
Appleton	31-39	41-51	18-22	14-16	X	X	X	X	X	X	X	X	X	X	X	X	X	X	X	X	X	X	
Applique	31-39	41-51	18-22	14-16	X	X	X	X	X	X	X		X			X	X	X	X	X	X	X	1968
Arabesque	49-59	67-81	31-39	23-29	X	X	X	X	X	X	X	X	X			X	X	X	X	X	X	X	1959
Arbor	18-22	23-29	10-12	7-9	X	X	X	X	X	X	X	X	X			X	X	X	X	X	X		
Arcadia, Blue, Gold Trim	35-43	50-60	23-29	17-21	X	X	X	X	X	X	X	X				X	X	X	X	X	X	X	1941
Arcadia, Green, Gold Trim	35-43	50-60	23-29	17-21	X	X	X	X	X	X	X	X				X	X	X	X	X	X	X	1941
Arcadia, Maroon, Gold Trim	35-43	50-60	23-29	17-21	X	X	X	X	X	X	X	X				X	X	X	X	X	X	X	1941
Arden	35-43	50-60	23-29	17-21	X	X	X	X	X	X	X	X	X	X		X	X	X	X	X	X	X	1941
Ariel	29-35	47-57	22-26	17-21	X	X	X	X	X	X	X	X		X		X	X	X	X	X	X	X	1971
Autumn	20-24	14-16	11-13	4-6	X	X	X	X	X	X	X	X	X	X	X	X	X	X	X	X	X	X	1955
Aztec	20-24	26-32	13-15	8-10	X	X	X	X	X	X	X	X	X	X	X	X	X	X	X	X	X	X	
Ballet	30-36	40-48	18-22	13-15	X	X	X	X	X	X	X	X	X	X	X	X	X	X	X	X	X	X	1956
Betsy	22-28	30-36	15-19	10-12	X	X	X	X	X	X	X	X	X	X	X	X	X	X	X	X	X		
Beverly	35-43	50-60	23-26	17-21	X	X	X	X	X	X	X	X	X	X	X	X	X	X	X	X	X	X	1941
Birchbark	31-39	41-51	18-22	14-16	X	X	X	X	X	X	X	X	X	X	X	X	X	X	X	X	X		
Bird 'N Hand	14-18	19-23	8-10	4-6	X	X	X	X	X	X	X	X	X			X	X	X	X	X	X	X	1968
Blue Bell	15-19	20-24	9-11	5-7							X	X	X										
Blue Dawn	17-21	22-26	9-11	5-7	X	X	X	X	X	X	X	X	X	X	X	X	X	X	X	X	X	X	
Blue Fancy	14-18	19-23	8-10	4-6	X	X	X	X	X	X	X	X				X	X	X	X	X	X		
Blue Ribbon	15-19	20-24	9-11	5-7	X	X	X	X	X	X	X	X	X	X	X	X	X	X	X	X	X		
Blueberry	18-22	23-29	10-12	7-9	X	X	X	X	X	X	X	X	X	X	X	X	X	X	X	X	X		
Bountiful	36-44	9-11	27-33	16-20	X	X	X	X	X	X	X	X	X	X	X	X	X	X	X	X	X	X	1979
Bouquet, Multicolor Floral	19-23	20-24	11-13	7-9	X	X	X	X	X	X	X	X				X	X	X	X	X	X		
Bouquet, Blue Floral, tan background	18-22	20-24	10-12	14-16	X	X	X	X	X	X	X	X				X	X	X	X	X	X		1980
Brentwood	31-39	41-51	31-39	14-16	X	X	X	X	X	X	X	X	X	X	X	X	X	X	X	X	X	X	1956
Brides Bouquet	23-29	32-40	14-18	11-13	X	X	X	X	X	X	X	X	X	X	X	X	X	X	X	X	X	X	
Bridgeton	19-23	20-24	11-13	7-9	X	X	X	X	X	X	X	X	X	X	X	X	X	X	X	X	X		
Brook, The	18-22	23-29	10-12	7-9	X	X	X	X	X	X	X	X	X	X	X	X	X	X	X	X	X		
Cafe Royal	18-22	14-18	13-15	11-13	X	X	X	X	X	X	X	X	X			X	X	X	X	X	X	X	1981
Calypso	30-36	40-48	18-22	13-15	X	X	X	X	X	X	X	X				X	X	X	X	X	X	X	c. 1970
Cameo	17-21	22-26	9-11	5-7	X	X	X	X	X	X	X	X	X	X	X	X	X	X	X	X	X	X	
Cameron	22-26	28-34	13-15	9-11	X	X	X	X	X	X	X	X	X	X	X	X	X	X	X	X	X	X	
Cantata	14-18	19-23	8-10	4-6	X	X	X	X	X	X	X	X				X	X	X	X	X	X		1965
Canton	32-40	45-55	22-26	16-20	X	X	X	X	X	X	X	X	X	X	X	X	X	X	X	X	X	X	1950
Capri	28-34	38-46	17-21	13-15	X	X	X	X	X	X	X	X	X	X	X	X	X	X	X	X	X	X	1959
Carmel	32-40	35-43	22-26	14-18	X	X	X	X	X	X	X	X	X	X	X	X	X	X	X	X	X	X	1952
Castile	32-40	45-55	22-26	16-20	X	X	X	X	X	X	X	X		X		X	X	X	X	X	X	X	1971
Chantilly	13-15	17-21	8-10	4-6	X	X	X	X	X	X	X	X	X	X	X	X	X	X	X	X	X	X	
Chelan	32-40	45-55	22-26	16-20	X	X	X	X	X	X	X	X	X	X	X	X	X	X	X	X	X	X	1950
Cherokee Rose, Wide Inner Gold Band	35-43	50-60	23-29	17-21	X	X	X	X	X	X	X	X	X	X	X	X	X	X	X	X	X	X	1942
Cherokee Rose, Green Band	35-43	50-60	23-29	17-21	X	X	X	X	X	X	X	X	X	X	X	X	X	X	X	X	X	X	1941
Cherokee Rose, Thin Inner Gold Band	35-43	50-60	23-29	17-21	X	X	X	X	X	X	X	X	X	X	X	X	X	X	X	X	X	X	1941
Cherry	20-24	26-32	13-15	8-10	X	X	X	X	X	X	X	X	X	X	X	X	X	X	X	X	X		
Chestnut	22-28	30-36	15-19	10-12	X	X	X	X	X	X	X	X	X	X	X	X	X	X	X	X	X	X	

Pattern Name	Dinner Plate	Cup & Saucer	Salad Plate	Bread & Butter Plate	Luncheon Plate	Creamer	Sugar Bowl	Oval Vegetable	Round Vegetable	Platters 10"-18"	Five Piece Place Setting	Fruit Bowl	Cereal Bowl	Soup Bowl	Cream Soup & Saucer	Gravy Boat	Butter Dish	Salt & Pepper	Teapot	Coffee Pot	Covered Vegetable	Demitasse	Date First Produced
Chestnut Weave	18-22	23-29	10-12	7-9	X	X	X	X	X	X	X	X	X			X	X	X	X	X	X	X	
Chocolate	15-19	20-24	9-11	6-7	X	X	X	X	X	X	X	X	X	X	X	X	X	X	X	X	X	X	
Christoval	17-21	22-26	9-11	5-7	X	X	X	X	X	X	X	X	X	X	X	X	X	X	X	X	X	X	
Cimarron	37-45	53-65	23-29	18-22	X	X	X	X	X	X	X	X	X	X	X	X	X	X	X	X	X	X	
Claremont	50-62	53-65	33-41	24-30	X	X	X	X	X	X	X	X	X	X	X	X	X	X	X	X	X	X	1952
Cloud Nine	14-18	19-23	8-10	4-6	X	X	X	X	X	X	X	X	X		X	X	X	X	X	X	X	X	1960
Coaching Days	18-22	23-29	10-12	7-9	X	X	X	X	X	X	X	X	X	X	X	X	X	X	X	X	X	X	
Concord	39-47	56-68	24-30	19-23	X	X	X	X	X	X	X	X	X	X	X	X	X	X	X	X	X	X	1952
Constantine	50-60	53-65	32-40	23-29	X	X	X	X	X	X	X	X		X		X	X	X	X	X	X	X	1967
Contours	88-108	88-108	62-76	45-55	X	X	X	X	X	X	X	X	X	X	X	X	X	X	X	X	X	X	1955
Corinthian	50-62	53-65	33-41	24-30	X	X	X	X	X	X	X	X	X	X	X	X	X	X	X	X	X	X	1961
Coronado, Aqua Glossy	15-19	20-24	9-11	5-7	X	X	X	X	X	X	X	X	X	X	X	X	X	X	X	X	X	X	1936
Coronado, Aqua Matte	15-19	20-24	9-11	5-7	X	X	X	X	X	X	X	X	X	X	X	X	X	X	X	X	X	X	1936
Coronado, Burgundy Glossy	15-19	20-24	9-11	5-7	X	X	X	X	X	X	X	X	X	X	X	X	X	X	X	X	X	X	1936
Coronado, Coral Glossy	15-19	20-24	9-11	5-7	X	X	X	X	X	X	X	X	X	X	X	X	X	X	X	X	X	X	1936
Coronado, Beige Matte	15-19	20-24	9-11	5-7	X	X	X	X	X	X	X	X	X	X	X	X	X	X	X	X	X	X	1936
Coronado, Gray Matte	15-19	20-24	9-11	5-7	X	X	X	X	X	X	X	X	X	X	X	X	X	X	X	X	X	X	1936
Coronado, Off White Glossy	15-19	20-24	9-11	5-7	X	X	X	X	X	X	X	X	X	X	X	X	X	X	X	X	X	X	1936
Coronado, Off White Matte	15-19	20-24	9-11	5-7	X	X	X	X	X	X	X	X	X	X	X	X	X	X	X	X	X	X	1936
Coronado, Yellow Glossy	15-19	20-24	9-11	5-7	X	X	X	X	X	X	X	X	X	X	X	X	X	X	X	X	X	X	1936
Coronado, Yellow Matte	15-19	20-24	9-11	5-7	X	X	X	X	X	X	X	X	X	X	X	X	X	X	X	X	X	X	1936
Cortina	20-24	26-32	13-15	8-10	X	X	X	X	X	X	X	X	X	X	X	X	X	X	X	X	X	X	1960
Country Craft, Almond Cream	15-19	20-24	9-11	5-7	X	X	X	X	X	X	X	X	X			X	X	X	X	X	X	X	
Country Craft, Blue Skies	15-19	20-24	9-11	5-7	X	X	X	X	X	X	X	X	X	X	X	X	X	X	X	X	X	X	
Country Craft, Russet Brown	15-19	20-24	9-11	5-7	X	X	X	X	X	X	X	X	X	X	X	X	X	X	X	X	X	X	
Country Craft, Peachy Pink	15-19	20-24	9-11	5-7	X	X	X	X	X	X	X	X	X	X	X	X	X	X	X	X	X	X	
Country Craft, Raspberry Cream	15-19	20-24	9-11	5-7	X	X	X	X	X	X	X	X	X	X	X	X	X	X	X	X	X	X	
Country French	18-22	23-29	10-12	7-9	X	X	X	X	X	X	X	X	X	X	X	X	X	X	X	X	X	X	
Countryside, Blue Scenery	18-22	23-29	10-12	7-9	X	X	X	X	X	X	X	X	X	X	X	X	X	X	X	X	X	X	
Creole	15-19	20-24	9-11	5-7	X	X	X	X	X	X	X	X	X			X	X	X	X	X	X	X	1973
Crinoline, Pink & Blue	31-39	41-51	18-22	14-16	X	X	X	X	X	X	X	X	X	X	X	X	X	X	X	X	X	X	
Crinoline, Yellow Flower	32-40	45-55	22-26	16-20	X	X	X	X	X	X	X	X		X		X	X	X	X	X	X	X	
Crown Jewel	34-42	47-57	22-26	17-21	X	X	X	X	X	X	X	X	X	X	X	X	X	X	X	X	X	X	1959
Daffodil	15-19	20-24	9-11	5-7				X	X	X	X	X											
Daisy	16-20	14-18	14-16	5-7	X	X	X	X	X	X	X	X	X	X	X	X	X	X	X	X	X	X	1960
Daisy Wreath	18-22	23-29	10-12	7-9	X	X	X	X	X	X	X	X	X			X	X	X	X	X	X	X	
Dawn	31-39	35-43	18-22	14-16	X	X	X	X	X	X	X	X	X	X	X	X	X	X	X	X	X	X	1954
Debut	31-39	41-51	18-22	14-16	X	X	X	X	X	X	X	X	X	X	X	X	X	X	X	X	X	X	1958
Del Mar	15-19	20-24	9-11	5-7	X	X	X	X	X	X	X	X	X			X	X	X	X	X	X	X	1937
Del Monte	34-42	47-57	22-26	17-21	X	X	X	X	X	X	X	X	X	X	X	X	X	X	X	X	X	X	1941
Del Rio	35-43	45-55	22-28	17-21	X	X	X	X	X	X	X	X	X	X	X	X	X	X	X	X	X	X	1956
Denmark	18-22	23-29	10-12	7-9	X	X	X	X	X	X	X	X	X	X		X	X	X	X	X	X	X	
Desert Rose, American	16-20	14-18	13-15	7-9	X	X	X	X	X	X	X	X	X	X		X	X	X	X	X	X	X	1941
Desert Rose, English	13-15	13-15	9-11	8-10	X	X	X	X	X	X	X	X	X	X	X	X	X	X	X	X	X	X	
Desert Sands	18-22	23-29	10-12	7-9	X	X	X	X	X	X	X	X	X	X	X	X	X	X	X	X	X	X	
Dogwood	18-22	23-29	10-12	7-9	X	X	X	X	X	X	X	X	X			X	X	X	X	X	X	X	1975
Duet	14-16	14-16	11-13	4-6	X	X	X	X	X	X	X	X	X			X	X	X	X	X	X	X	1956
Dusty Rose	20-24	26-32	13-15	8-10	X	X	X	X	X	X	X	X	X	X	X	X	X	X	X	X	X	X	
Dutch Weave	18-22	23-29	10-12	7-9	X	X	X	X	X	X	X	X	X			X	X	X	X	X	X	X	
Earth Born	18-22	23-29	10-12	7-9	X	X	X	X	X	X	X	X	X	X	X	X	X	X	X	X	X	X	
Echo	13-15	17-21	8-10	4-6	X	X	X	X	X	X	X	X	X	X	X	X	X	X	X	X	X	X	1954
Eclipse White	18-22	23-29	10-12	7-9	X	X	X	X	X	X	X	X	X	X	X	X	X	X	X	X	X	X	1954
El Dorado	13-15	17-21	8-10	4-6	X	X	X	X	X	X	X	X	X	X	X	X	X	X	X	X	X	X	1966

Pattern Name	Dinner Plate	Cup & Saucer	Salad Plate	Bread & Butter Plate	Luncheon Plate	Creamer	Sugar Bowl	Oval Vegetable	Round Vegetable	Platters 10"-18"	Five Piece Place Setting	Fruit Bowl	Cereal Bowl	Soup Bowl	Cream Soup & Saucer	Gravy Boat	Butter Dish	Salt & Pepper	Teapot	Coffee Pot	Covered Vegetable	Demitasse	Date First Produced
El Patio, Apple Green	15-19	20-24	9-11	5-7	X	X	X	X	X	X	X	X	X	X	X	X	X	X	X	X	X	X	1934
El Patio, Coral Glossy	15-19	20-24	9-11	5-7	X	X	X	X	X	X	X	X	X	X	X	X	X	X	X	X	X	X	1934
El Patio, Coral Matte	15-19	20-24	9-11	5-7	X	X	X	X	X	X	X	X	X	X	X	X	X	X	X	X	X	X	1934
El Patio, Gray	15-19	20-24	9-11	5-7	X	X	X	X	X	X	X	X	X	X	X	X	X	X	X	X	X	X	1934
El Patio, Red	18-22	23-29	10-12	7-9	X	X	X	X	X	X	X	X	X	X	X	X	X	X	X	X	X	X	1934
El Patio, Turquoise	15-19	20-24	9-11	5-7	X	X	X	X	X	X	X	X	X	X	X	X	X	X	X	X	X	X	1934
El Patio, White Glossy	15-19	20-24	9-11	5-7	X	X	X	X	X	X	X	X	X	X	X	X	X	X	X	X	X	X	1934
El Patio, White Matte	15-19	20-24	9-11	5-7	X	X	X	X	X	X	X	X	X	X	X	X	X	X	X	X	X	X	1934
El Patio, Bright Yellow Glossy	15-19	20-24	9-11	5-7	X	X	X	X	X	X	X	X	X	X	X	X	X	X	X	X	X	X	1934
El Patio, Bright Yellow Matte	15-19	20-24	9-11	5-7	X	X	X	X	X	X	X	X	X	X	X	X	X	X	X	X	X	X	1934
El Patio, Pale Yellow Glossy	18-22	23-29	10-12	7-9	X	X	X	X	X	X	X	X	X	X	X	X	X	X	X	X	X	X	1934
El Patio, Pale Yellow Matte	18-22	23-29	10-12	7-9	X	X	X	X	X	X	X	X	X	X	X	X	X	X	X	X	X	X	1934
Elsinore	35-43	50-60	23-29	17-21	X	X	X	X	X	X	X	X	X	X	X	X	X	X	X	X	X	X	1946
Emerald Isle	18-22	23-29	10-12	7-9	X	X	X	X	X	X	X	X	X		X	X	X	X	X	X	X	X	1965
Encanto Blank	28-34	38-46	17-21	13-15	X	X	X	X	X	X	X	X	X	X	X	X	X	X	X	X	X		
Encanto Rose	35-43	8-46	22-28	17-21	X	X	X	X	X	X	X	X	X	X	X	X	X	X	X	X	X	X	1954
Encore	28-34	38-46	17-21	13-15	X	X	X	X	X	X	X	X	X	X	X	X	X	X	X	X	X	X	1956
Equus	30-36	40-48	18-22	13-15	X	X	X	X	X	X	X	X	X	X	X	X	X	X	X	X	X	X	
Erica	18-22	23-29	10-12	7-9	X	X	X	X	X	X	X	X	X	X	X	X	X	X	X	X	X	X	
Exotic Garden	32-40	45-55	22-26	16-20																			
Fan Tan	14-18	19-23	8-10	4-6		X	X	X	X	X	X	X	X			X	X	X	X	X	X	X	1961
Ferndel	18-22	23-29	10-12	7-9	X	X	X	X	X	X	X	X	X	X	X	X	X	X	X	X	X	X	1957
Fiesta	26-32	37-45	17-21	12-14	X	X	X	X	X	X	X	X	X	X	X	X	X	X	X	X			
Fire Dance	18-22	23-29	10-12	7-9	X	X	X	X	X	X	X	X	X	X	X	X	X	X	X	X			
Floral	17-21	14-18	9-11	9-11		X	X	X	X	X	X	X	X	X		X	X	X	X	X			1971
Floral Sculptures	18-22	23-29	10-12	7-9	X	X	X	X	X	X	X	X	X		X	X	X	X	X	X	X		
Flower Garden	32-40	45-55	22-26	16-20	X	X	X	X	X	X	X	X	X	X	X	X	X	X	X	X	X	X	
Forget-Me-Not	32-40	20-24	18-22	14-18	X	X	X	X	X	X	X	X			X	X	X	X	X	X			1978
Fremont	37-45	53-65	23-29	18-22	X	X	X	X	X	X	X	X	X	X	X	X	X	X	X	X	X	X	1942
French Floral	18-22	23-29	10-12	7-9	X	X	X	X	X	X	X	X	X	X	X	X	X	X	X	X	X		
Fresh Fruit	40-48	20-24	23-29	18-22	X	X	X	X	X	X	X	X	X			X	X	X	X	X			1979
Fruit, Large Fruit	13-15	17-21	8-10	4-6	X	X	X	X	X	X	X	X	X			X	X	X	X	X			
Fruit, Small Fruit	50-60	32-40	34-42	20-24	X	X	X	X	X	X	X	X	X	X		X	X	X	X		X		
Fruit Basket	15-19	20-24	9-11	5-7	X	X	X	X	X	X	X	X	X	X	X	X	X	X	X	X	X	X	
Gabrielle	32-40	45-55	22-26	16-20	X	X	X	X	X	X	X	X		X		X	X	X	X	X	X	X	1969
Garden Party	18-22	23-29	10-12	7-9	X	X	X	X	X	X	X	X				X	X	X	X	X	X		1974
Gingersnap	18-22	23-29	10-12	7-9	X	X	X	X	X	X	X	X				X	X	X	X	X	X		1974
Glenfield	19-23	25-31	11-13	7-9	X	X	X	X	X	X	X	X	X	X	X	X	X	X	X	X	X	X	1961
Gold Band	34-42	47-57	22-26	17-21	X	X	X	X	X	X	X	X	X	X	X	X	X	X	X	X	X	X	
Gold Leaves	32-40	45-55	22-26	16-20	X	X	X	X	X	X	X	X	X	X	X	X	X	X	X	X	X	X	1957
Gold Poppies	18-22	23-29	10-12	7-9	X	X	X	X	X	X	X	X	X	X	X	X	X	X	X	X	X		
Golden Weave	15-19	20-24	9-11	5-7	X	X	X	X	X	X	X	X				X	X	X	X	X	X		
Gourmet	18-22	23-29	10-12	7-9	X	X	X	X	X	X	X	X				X	X	X	X	X	X		1972
Granada	39-47	56-68	24-30	19-23	X	X	X	X	X	X	X	X	X	X	X	X	X	X	X	X	X	X	1950
Granville	31-39	41-51	18-22	14-16	X	X	X	X	X	X	X	X	X	X	X	X	X	X	X	X	X		
Grayson	19-23	25-31	11-13	7-9	X	X	X	X	X	X	X	X	X	X	X	X	X	X	X	X	X		
Greenhouse series					X	X	X	X	X							X	X	X	X	X	X		1975
Hacienda, Gold	15-19	14-18	13-15	6-8	X	X	X	X	X	X	X	X	X			X	X	X	X	X	X		1964
Hacienda, Green	15-19	14-18	9-11	5-7	X	X	X	X	X	X	X	X	X			X	X	X	X	X	X		1965
Hampten	22-28	30-36	15-19	10-12	X	X	X	X	X	X	X	X	X	X	X	X	X	X	X	X	X	X	
Happy Talk	14-18	19-23	8-10	4-6	X	X	X	X	X	X	X	X	X			X	X	X	X	X	X	X	1959
Harvest Gold	20-24	26-32	13-15	8-10	X	X	X	X	X	X	X	X	X		X	X	X	X	X	X	X	X	
Hawaii	15-19	20-24	9-11	5-7	X	X	X	X	X	X	X	X	X			X	X	X	X	X	X	X	1967

Pattern Name	Dinner Plate	Cup & Saucer	Salad Plate	Bread & Butter Plate	Luncheon Plate	Creamer	Sugar Bowl	Oval Vegetable	Round Vegetable	Platters 10"-18"	Five Piece Place Setting	Fruit Bowl	Cereal Bowl	Soup Bowl	Cream Soup & Saucer	Gravy Boat	Butter Dish	Salt & Pepper	Teapot	Coffee Pot	Covered Vegetable	Demitasse	Date First Produced
Heritage	20-24	20-24	14-16	8-10	X	X	X	X	X	X	X	X	X			X	X	X	X	X	X		
Homeland	18-22	23-29	10-12	7-9	X	X	X	X	X	X	X	X	X	X	X	X	X	X	X	X	X	X	
Homeware, Chocolate	18-22	23-29	10-12	7-9	X	X	X	X	X	X	X	X	X	X	X	X	X	X	X	X	X	X	
Homeware, Pumpkin	18-22	23-29	10-12	7-9	X	X	X	X	X	X	X	X	X	X	X	X	X	X	X	X	X	X	
Homeware, White	18-22	23-29	10-12	7-9	X	X	X	X	X	X	X	X	X	X	X	X	X	X	X	X	X	X	c. 1976
Honeydew	18-22	23-29	10-12	7-9	X	X	X	X	X	X	X	X	X			X	X	X	X	X	X		
Hunter, The, Blue	17-21	22-26	9-11	5-7	X	X	X	X	X	X	X	X	X	X		X	X	X	X	X	X		
Hunter, The, Multicolored	17-21	22-26	9-11	5-7	X	X	X	X	X	X	X	X	X	X		X	X	X	X	X	X		
Huntington	40-50	45-55	25-31	18-22	X	X	X	X	X	X	X	X	X	X		X	X	X	X	X	X		
Huntington Rose	40-50	45-55	25-31	18-22	X	X	X	X	X	X	X	X	X	X	X	X	X	X	X	X	X	X	1955
Indian Summer	19-23	25-31	11-13	7-9	X	X	X	X	X	X	X	X				X	X	X	X	X	X		
Indigo	43-53	47-57	26-32	20-24	X	X	X	X	X	X	X			X		X	X	X	X	X	X	X	1970
Interlude	31-39	41-51	18-22	14-16	X	X	X	X	X	X	X	X	X	X	X	X	X	X	X	X	X	X	1960
It's A Breeze	14-18	19-23	8-10	4-6	X	X	X	X	X	X	X	X				X	X	X	X	X	X		1959
Ivy	36-44	25-31	22-26	9-11	X	X	X	X	X	X	X	X	X	X	X	X	X	X	X	X	X		1948
Jamoca	15-19	20-24	9-11	5-7		X	X	X	X	X	X	X	X			X	X	X	X	X	X		
Kaolina	18-22	23-29	10-12	7-9	X	X	X	X	X	X	X	X	X	X	X	X	X	X	X	X	X	X	
Kasmir	39-47	56-68	24-30	19-23	X	X	X	X	X	X	X	X	X	X	X	X	X	X	X	X	X	X	1969
Kismet	23-29	32-40	14-18	11-13	X	X	X	X	X	X	X	X	X	X	X	X	X	X	X	X	X		
Laguna	32-40	45-55	22-26	16-20	X	X	X	X	X	X	X	X	X	X	X	X	X	X	X	X	X	X	1941
Larkspur	18-22	23-29	10-12	7-9	X	X	X	X	X	X	X	X	X			X	X	X	X	X	X		1958
Lattice	18-22	23-29	10-12	7-9	X	X	X	X	X	X	X	X			X	X	X	X	X	X	X		
Leeds	15-19	20-24	9-11	5-7	X	X	X	X	X	X	X	X	X	X	X	X	X	X	X	X	X		
Lily of the Valley	28-34	38-46	17-21	13-15	X	X	X	X	X	X	X	X	X	X	X	X	X	X	X	X	X		
Lorraine, Green	39-47	56-68	24-30	19-23	X	X	X	X	X	X	X	X	X	X	X	X	X	X	X	X	X	X	1946
Lorraine, Maroon	37-45	53-65	23-29	18-22	X	X	X	X	X	X	X	X	X	X	X	X	X	X	X	X	X	X	1946
Love Bird	23-29	32-40	14-18	11-13	X	X	X	X	X	X	X	X	X	X	X	X	X	X	X	X	X		
Lucerne	20-24	26-32	13-15	8-10	X	X	X	X	X	X	X	X	X	X	X	X	X	X	X	X	X	X	1959
Madeira	16-20	16-20	10-12	6-8		X	X	X	X	X	X	X			X	X	X	X	X				1967
Madrigal	41-51	59-71	28-34	21-25	X	X	X	X	X	X	X	X	X	X	X	X	X	X	X	X	X	X	1973
Magnolia	32-40	45-55	22-26	16-20	X	X	X	X	X	X	X	X	X	X	X	X	X	X	X	X	X	X	1952
Malaya	18-22	23-29	10-12	7-9	X	X	X	X	X	X	X	X	X	X	X	X	X	X	X	X	X	X	1959
Malibu	15-19	20-24	9-11	5-7	X	X	X	X	X	X	X	X			X	X	X	X	X	X		1964	
Mandalay, Blue Design	41-51	59-71	28-34	21-25	X	X	X	X	X	X	X	X	X	X	X	X	X	X	X	X	X	X	c. 1973
Mandalay, Rust & Yellow Flowers	18-22	23-29	10-12	7-9	X	X	X	X	X	X	X	X	X	X	X	X	X	X	X	X	X	X	c. 1973
Mandarin	19-23	25-31	11-13	7-9	X	X	X	X	X	X	X	X	X	X	X	X	X	X	X	X			
Mariana	28-34	38-46	17-21	13-15	X	X	X	X	X	X	X	X			X	X	X	X	X	X			
Mariposa	59-71	62-76	38-46	26-32	X	X	X	X	X	X	X	X	X	X	X	X	X	X	X	X	X		1949
Martinque	34-42	47-57	22-26	17-21	X	X	X	X	X	X	X	X	X	X	X	X	X	X	X	X	X		1966
Mayflower	18-22	23-29	10-12	7-9	X	X	X	X	X	X	X	X	X	X	X	X	X	X	X	X			
Maypole	15-19	20-24	9-11	5-7	X	X	X	X	X	X	X	X			X	X	X	X	X	X		1974	
Maytime	17-21	22-26	9-11	5-7	X	X	X	X	X	X	X	X			X	X	X	X	X	X			
Meadow Rose	18-22	14-18	13-15	11-13	X	X	X	X	X	X	X	X	X			X	X	X	X	X	X	X	1977
Medallion	18-22	23-29	10-12	7-9	X	X	X	X	X	X	X				X	X	X	X	X	X	X	1962	
Melody	15-19	20-24	9-11	5-7	X	X	X	X	X	X	X	X	X		X	X	X	X	X	X			
Melrose	22-28	30-36	15-19	10-12	X	X	X	X	X	X	X	X	X	X	X	X	X	X	X	X	X		1961
Menagerie, Black	28-34	38-46	17-21	13-15	X	X	X	X	X	X	X	X	X	X	X	X	X	X	X	X	X		
Menagerie, Blue	28-34	38-46	17-21	13-15	X	X	X	X	X	X	X	X	X	X	X	X	X	X	X	X	X		
Merced shape	24-30	35-43	16-20	12-14	X	X	X	X	X	X	X	X	X	X	X	X	X	X	X	X	X		1940
Merry-Go-Round	14-18	19-23	8-10	4-6	X	X	X	X	X	X	X	X			X	X	X	X	X	X		1959	
Mesa, Fine China	31-39	41-51	18-22	14-16	X	X	X	X	X	X	X	X	X	X	X	X	X	X	X	X	X		1950
Mesa, Earthenware	13-15	17-21	8-10	4-6	X	X	X	X	X	X	X	X	X	X	X	X	X	X	X	X	X		
Metropolitan, Gray	15-19	20-24	9-11	5-7	X	X	X	X	X	X	X	X	X	X	X	X	X	X	X	X	X	X	1940

Pattern Name	Dinner Plate	Cup & Saucer	Salad Plate	Bread & Butter Plate	Luncheon Plate	Creamer	Sugar Bowl	Oval Vegetable	Round Vegetable	Platters 10"-18"	Five Piece Place Setting	Fruit Bowl	Cereal Bowl	Soup Bowl	Cream Soup & Saucer	Gravy Boat	Butter Dish	Salt & Pepper	Teapot	Coffee Pot	Covered Vegetable	Demitasse	Date First Produced
Metropolitan, Mauve	15-19	20-24	9-11	5-7	X	X	X	X	X	X	X	X	X	X	X	X	X	X	X	X	X	X	1940
Minaret	39-47	56-68	24-30	19-23	X	X	X	X	X	X	X	X	X	X	X	X	X	X	X	X	X	X	c. 1973
Midnight Mist	50-60	53-65	32-40	23-29	X	X	X	X	X	X	X		X		X	X	X	X	X	X	X	X	1966
Mint Weave	18-22	23-29	10-12	7-9	X	X	X	X	X	X	X	X			X	X	X	X	X	X	X		
Mirasol	15-19	20-24	9-11	5-7	X	X	X	X	X	X	X	X			X	X	X	X	X	X	X		1975
Monaco	37-45	53-65	23-29	18-22	X	X	X	X	X	X	X	X	X	X	X	X	X	X	X	X	X	X	1968
Montecito	32-40	42-52	20-24	14-18	X	X	X	X	X	X	X	X	X	X	X	X	X	X	X	X	X	X	1957
Monterey	32-40	45-55	22-26	16-20	X	X	X	X	X	X	X	X	X	X	X	X	X	X	X	X	X	X	1949
Moon Glow	50-60	53-65	32-40	23-29	X	X	X	X	X	X	X		X		X	X	X	X	X	X	X	X	1966
Moondance	15-19	14-18	8-10	5-7	X	X	X	X	X	X	X	X			X	X	X	X	X	X	X		1972
Morning Glory	24-30	35-43	16-20	12-14	X	X	X	X	X	X	X	X	X	X	X	X	X	X	X	X	X	X	
Morocco	35-43	50-60	23-29	17-21	X	X	X	X	X	X	X	X	X	X	X	X	X	X	X	X	X	X	
Mountain Laurel	35-43	50-60	23-29	17-21	X	X	X	X	X	X	X	X	X	X	X	X	X	X	X	X	X	X	1941
Narcissus	22-28	30-36	15-19	10-12	X	X	X	X	X	X	X	X	X	X	X	X	X	X	X	X	X	X	
Nassau	23-29	32-40	14-18	11-13	X	X	X	X	X	X	X	X	X	X	X	X	X	X	X	X	X	X	1959
Newport	28-34	38-46	17-21	13-15	X	X	X	X	X	X	X	X		X	X	X	X	X	X	X	X	X	1959
Nightingale	35-43	50-60	23-29	17-21	X	X	X	X	X	X	X	X	X	X	X	X	X	X	X	X	X	X	1966
Nouvelle Ebony	41-51	59-71	28-34	21-25	X	X	X	X	X	X	X		X		X	X	X	X	X	X	X	X	1972
Nouvelle Ivory	39-47	56-68	24-30	19-23	X	X	X	X	X	X	X		X		X	X	X	X	X	X	X	X	1972
Nut Tree	15-19	20-24	9-11	5-7		X	X	X	X	X	X	X			X	X	X	X	X	X	X		1970
Nutmeg	24-30	35-43	16-20	12-14	X	X	X	X	X	X	X	X			X	X	X	X	X	X	X	X	
Oasis	15-19	20-24	9-11	5-7	X	X	X	X	X	X	X	X	X	X	X	X	X	X	X	X	X	X	1955
October	32-40	20-24	18-22	14-18	X	X	X	X	X	X	X				X	X	X	X	X	X	X		1977
Old Chelsea	18-22	23-29	10-12	7-9	X	X	X	X	X	X	X	X	X	X	X	X	X	X	X	X	X		
Olympic	37-45	53-65	23-29	18-22	X	X	X	X	X	X	X	X	X	X	X	X	X	X	X	X	X	X	1950
Ondine	39-47	56-68	24-30	19-23	X	X	X	X	X	X	X	X	X	X	X	X	X	X	X	X	X	X	c. 1973
Orient	22-28	30-36	15-19	10-12	X	X	X	X	X	X	X	X	X	X	X	X	X	X	X	X	X	X	
Orleans	17-21	22-26	9-11	5-7	X	X	X	X	X	X	X	X	X	X	X	X	X	X	X	X	X	X	
Overture	32-40	42-52	20-24	14-18	X	X	X	X	X	X	X		X		X	X	X	X	X	X	X	X	
Palo Alto	32-40	45-55	22-26	16-20	X	X	X	X	X	X	X	X	X	X	X	X	X	X	X	X	X	X	1950
Palomar, Robin's Egg Blue	32-40	45-55	22-26	16-20	X	X	X	X	X	X	X	X	X	X	X	X	X	X	X	X	X	X	
Palomar, Gray, Gold Trim	32-40	45-55	22-26	16-20	X	X	X	X	X	X	X	X	X	X	X	X	X	X	X	X	X	X	
Palomar, Gray, Platinum Trim	32-40	45-55	22-26	16-20	X	X	X	X	X	X	X	X	X	X	X	X	X	X	X	X	X	X	
Palomar, Jasper (Light Green)	32-40	45-55	22-26	16-20	X	X	X	X	X	X	X	X	X	X	X	X	X	X	X	X	X	X	
Palomar, Jade (Dark Green)	32-40	45-55	22-26	16-20	X	X	X	X	X	X	X	X	X	X	X	X	X	X	X	X	X	X	
Palomar, Cameo Pink	34-42	47-57	22-26	17-21	X	X	X	X	X	X	X	X	X	X	X	X	X	X	X	X	X	X	
Palomar, Yellow	32-40	45-55	22-26	16-20	X	X	X	X	X	X	X	X	X	X	X	X	X	X	X	X	X	X	
Papaya	18-22	23-29	10-12	7-9	X	X	X	X	X	X	X		X		X	X	X	X	X	X	X	X	
Patrician	35-43	50-60	23-29	17-21	X	X	X	X	X	X	X	X	X	X	X	X	X	X	X	X	X	X	1961
Paynsley	22-28	30-36	15-19	10-12	X	X	X	X	X	X	X	X	X	X	X	X	X	X	X	X	X	X	
Peach Blossom	28-34	38-46	17-21	13-15	X	X	X	X	X	X	X	X	X	X	X	X	X	X	X	X	X	X	
Peach Tree	17-21	22-26	9-11	5-7	X	X	X	X	X	X	X	X	X	X	X	X	X	X	X	X	X	X	
Pebble Beach	15-19	14-18	8-10	5-7		X	X	X	X	X	X	X			X	X	X	X	X	X	X		1969
Petalpoint	34-42	47-57	22-26	17-21	X	X	X	X	X	X	X	X		X	X	X	X	X	X	X	X	X	1972
Pickwick	14-18	19-23	8-10	4-6	X	X	X	X	X	X	X	X			X	X	X	X	X	X	X	X	1965
Picnic	17-21	22-26	9-11	5-7	X	X	X	X	X	X	X	X			X	X	X	X	X	X	X		c. 1973
Piedmont	58-70	80-98	38-46	28-34	X	X	X	X	X	X	X	X	X	X	X	X	X	X	X	X	X	X	
Pink Vista	15-19	20-24	9-11	5-7	X	X	X	X	X	X	X	X	X	X	X	X	X	X	X	X	X	X	
Pink-A-Dilly	14-18	19-23	8-10	4-6	X	X	X	X	X	X	X	X	X		X	X	X	X	X	X	X	X	1959
Platina	38-46	47-57	26-32	19-23	X	X	X	X	X	X	X	X	X	X	X	X	X	X	X	X	X	X	1961
Platinum Band	38-46	35-43	22-26	16-20	X	X	X	X	X	X	X	X	X	X	X	X	X	X	X	X	X	X	
Polynesia	24-30	35-43	16-20	12-14	X	X	X	X	X	X	X	X	X	X	X	X	X	X	X	X	X	X	
Pomegranite	18-22	23-29	10-12	7-9	X	X	X	X	X	X	X	X	X		X	X	X	X	X	X	X	X	1954

Pattern Name	Dinner Plate	Cup & Saucer	Salad Plate	Bread & Butter Plate	Luncheon Plate	Creamer	Sugar Bowl	Oval Vegetable	Round Vegetable	Platters 10"-18"	Five Piece Place Setting	Fruit Bowl	Cereal Bowl	Soup Bowl	Cream Soup & Saucer	Gravy Boat	Butter Dish	Salt & Pepper	Teapot	Coffee Pot	Covered Vegetable	Demitasse	Date First Produced
Poppy, Yellow Flowers	15-19	20-24	9-11	5-7							X	X	X										
Poppy, Yellow/Purple Flowers	45-55	32-40	29-35	17-21	X	X	X	X	X	X	X	X	X			X	X	X	X			X	
Quadrille	31-39	41-51	18-22	14-16	X	X	X	X	X	X	X	X				X	X	X	X	X	X	X	1971
Radiance	17-21	22-26	9-11	5-7	X	X	X	X	X	X	X	X				X	X	X	X	X	X	X	1958
Rafiki, Black	28-34	38-46	17-21	13-15	X	X	X	X	X	X	X	X	X	X	X	X	X	X	X	X	X	X	
Rafiki, Blue	28-34	38-46	17-21	13-15	X	X	X	X	X	X	X	X	X	X	X	X	X	X	X	X	X	X	
Reflections, Yellow, Green Floral Center	17-21	22-26	9-11	5-7	X	X	X	X	X	X	X	X	X	X	X	X	X	X	X	X	X	X	
Reflections, Black	17-21	22-26	9-11	5-7	X	X	X	X	X	X	X	X				X	X	X	X	X			
Reflections, Blue	17-21	22-26	9-11	5-7	X	X	X	X	X	X	X	X				X	X	X	X	X			
Reflections, Burgundy	17-21	22-26	9-11	5-7	X	X	X	X	X	X	X	X				X	X	X	X	X			
Reflections, Jade	17-21	22-26	9-11	5-7	X	X	X	X	X	X	X	X				X	X	X	X	X			
Reflections, Lilac	17-21	22-26	9-11	5-7	X	X	X	X	X	X	X	X				X	X	X	X	X			
Reflections, Pink	17-21	22-26	9-11	5-7	X	X	X	X	X	X	X	X				X	X	X	X	X			
Reflections, Peach	17-21	22-26	9-11	5-7	X	X	X	X	X	X	X	X				X	X	X	X	X			
Reflections, Sand	17-21	22-26	9-11	5-7	X	X	X	X	X	X	X	X				X	X	X	X	X			
Reflections, Silver Gray	17-21	22-26	9-11	5-7	X	X	X	X	X	X	X	X				X	X	X	X	X			
Reflections, Smoke Gray	17-21	22-26	9-11	5-7	X	X	X	X	X	X	X	X				X	X	X	X	X			
Reflections, White	17-21	22-26	9-11	57	X	X	X	X	X	X	X	X				X	X	X	X	X			
Reflections, Yellow	17-21	22-26	9-11	5-7	X	X	X	X	X	X	X	X	X	X	X	X	X	X	X	X	X	X	
Regalia	32-40	45-55	22-26	16-20	X	X	X	X	X	X	X	X	X	X	X	X	X	X	X	X	X	X	1968
Regency	24-30	35-43	16-20	12-14	X	X	X	X	X	X	X	X	X	X	X	X	X	X	X	X	X	X	1953
Renaissance Crown, Green Border	49-59	53-65	31-39	23-29	X	X	X	X	X	X	X	X				X	X	X	X	X	X	X	1952
Renaissance Gold, Gold Border	53-65	59-71	35-43	26-32	X	X	X	X	X	X	X	X				X	X	X	X	X	X	X	1962
Renaissance Gray, Gray Border	37-45	47-57	23-29	18-22	X	X	X	X	X	X	X	X				X	X	X	X	X	X	X	1949
Renaissance Platinum, Platinum Trim	41-51	45-55	29-35	22-26	X	X	X	X	X	X	X	X				X	X	X	X	X	X	X	1962
Royal Renaissance, Blue Border	58-70	80-98	38-46	28-34	X	X	X	X	X	X	X	X				X	X	X	X	X	X	X	1968
Ridgewood	35-43	50-60	23-29	17-21	X	X	X	X	X	X	X	X	X	X	X	X	X	X	X	X	X	X	
Rondelay	35-43	50-60	23-29	17-21	X	X	X	X	X	X	X	X	X	X	X	X	X	X	X	X	X	X	1962
Rose Trellis	14-18	19-23	8-10	4-6	X	X	X	X	X	X	X	X	X	X	X	X	X	X	X	X	X	X	
Rosette	18-22	20-24	10-12	14-16	X	X	X	X	X	X	X	X				X	X	X	X	X	X	X	1980
Rossmore	35-43	50-60	23-29	17-21	X	X	X	X	X	X	X	X	X	X	X	X	X	X	X	X	X	X	1968
Rustic England	18-22	23-29	10-12	7-9	X	X	X	X	X	X	X	X	X	X	X	X	X	X	X	X	X	X	
San Fernando	17-21	22-26	9-11	5-7	X	X	X	X	X	X	X	X	X	X	X	X	X	X	X	X	X	X	
Sandalwood	34-42	47-57	22-26	17-21	X	X	X	X	X	X	X	X	X	X	X	X	X	X	X	X	X	X	1952
Sandman	18-22	23-29	10-12	7-9	X	X	X	X	X	X	X	X	X	X	X	X	X	X	X	X	X	X	
Sandstone	18-22	23-29	10-12	7-9	X	X	X	X	X	X	X	X	X	X	X	X	X	X	X	X	X	X	
Saraband	18-22	23-29	10-12	7-9	X	X	X	X	X	X	X	X	X	X	X	X	X	X	X	X	X	X	
Sea Sculpture, Sand Color (all patterns)	20-24	20-24		9-11																			
Sea Sculpture, White Color (all patterns)	23-29	22-28		11-13																			
Sea Sculpture, Sand Dollar, Sand Color					X																		
Sea Sculpture, Sand Dollar, White Color					X																		
Sea Sculpture, Sea Urchin, Sand					X																		
Sea Sculpture, Sea Urchin, White					X																		
Sea Sculpture, Fan Shell, Sand					X																		
Sea Sculpture, Fan Shell, White					X																		
Sea Sculpture, Nautilus, Sand					X																		
Sea Sculpture, Nautilus, White					X																		
Sea Sculpture, Primary, Sand					X	X	X		X	X	X	X				X	X	X	X			X	
Sea Sculpture, Primary, White					X	X	X		X	X	X	X				X	X	X	X			X	
Sea Sculpture, Conch, Sand					X																		
Sea Sculpture, Conch, White					X																		
Shady Lane	18-22	23-29	10-12	7-9	X	X	X	X	X	X	X	X	X	X	X	X	X	X	X	X	X	X	
Shalimar	45-55	62-76	31-37	22-28	X	X	X	X	X	X	X	X	X	X	X	X	X	X	X	X	X	X	c. 1973

155

Pattern Name	Dinner Plate	Cup & Saucer	Salad Plate	Bread & Butter Plate	Luncheon Plate	Creamer	Sugar Bowl	Oval Vegetable	Round Vegetable	Platters 10"-18"	Five Piece Place Setting	Fruit Bowl	Cereal Bowl	Soup Bowl	Cream Soup & Saucer	Gravy Boat	Butter Dish	Salt & Pepper	Teapot	Coffee Pot	Covered Vegetable	Demitasse	Date First Produced
Shasta	35-43	50-60	23-29	17-21	X	X	X	X	X	X	X	X	X	X	X	X	X	X	X	X	X	X	1942
Sierra, Fine China	39-47	56-68	24-30	19-23	X	X	X	X	X	X	X	X	X	X	X	X	X	X	X	X	X	X	1950
Sierra, Earthenware	13-15	17-21	8-10	4-6	X	X	X	X	X	X	X	X	X	X	X	X	X	X	X	X	X		
Sierra Sand	15-19	20-24	9-11	5-7	X	X	X	X	X	X	X	X				X	X	X	X	X	X		
Silkstone	15-19	20-24	9-11	5-7	X	X	X	X	X	X	X	X	X	X		X	X	X	X	X	X		
Silver Lining	31-39	41-51	18-22	14-16	X	X	X	X	X	X	X			X		X	X	X	X	X	X	X	1971
Silver Mist	30-36	40-48	18-22	13-15	X	X	X	X	X	X	X	X	X	X	X	X	X	X	X	X	X	X	1962
Silver Pine	29-35	32-40	18-22	11-13	X	X	X	X	X	X	X	X	X	X	X	X	X	X	X	X	X	X	1955
Simplicity	22-28	30-36	15-19	10-12	X	X	X	X	X	X	X	X	X			X	X	X	X	X	X	X	c. 1961
Snow Flakes	18-22	23-29	10-12	7-9	X	X	X	X	X	X	X	X	X	X	X	X	X	X	X	X	X	X	
Snow Pine	22-28	30-36	15-19	10-12	X	X	X	X	X	X	X	X	X	X	X	X	X	X	X	X	X	X	1961
Somerset	35-43	50-60	23-29	17-21	X	X	X	X	X	X	X	X	X	X	X	X	X	X	X	X	X	X	1959
Sonora	37-45	53-65	23-29	18-22	X	X	X	X	X	X	X	X	X	X	X	X	X	X	X	X	X		
Spice	17-21	22-26	9-11	5-7	X	X	X	X	X	X	X	X	X			X	X	X	X	X	X		1961
Spring Song	15-19	20-24	9-11	5-7	X	X	X	X	X	X	X	X	X	X	X	X	X	X	X	X	X		1958
Spruce	32-40	45-55	22-26	16-20	X	X	X	X	X	X	X	X	X	X	X	X	X	X	X	X	X	X	1952
St. Claire	24-30	35-43	16-20	12-14	X	X	X	X	X	X	X	X	X	X	X	X	X	X	X	X	X	X	
St. Louis	23-29	32-40	14-18	11-13	X	X	X	X	X	X	X	X	X	X	X	X	X	X	X	X	X		
St. Moritz, Cosmopolitan	22-28	30-36	15-19	10-12	X	X	X	X	X	X	X	X	X	X	X	X	X	X	X	X	X	X	1960
Stanfield	19-23	25-31	11-13	7-9	X	X	X	X	X	X	X	X	X	X	X	X	X	X	X	X	X		
Starburst	14-18	14-18	16-20	4-6	X	X	X	X	X	X	X	X			X	X	X	X	X	X	X		1954
Starry Night	53-65	59-71	35-43	26-32	X	X	X	X	X	X	X	X	X	X	X	X	X	X	X	X	X	X	1952
Strathmore	22-28	30-36	15-19	10-12	X	X	X	X	X	X	X	X	X	X	X	X	X	X	X	X	X	X	
Strawberry Fair	32-40	25-31	18-22	14-18	X	X	X	X	X	X	X	X				X	X	X	X	X	X	X	1979
Strawberry Time	32-40	25-31	18-22	14-18	X	X	X	X	X	X	X	X				X	X	X	X	X	X	X	1983
Sun Song	15-19	20-24	9-11	5-7	X	X	X	X	X	X	X	X	X	X	X	X	X	X	X	X	X	X	c. 1970
Sundance	15-19	14-18	7-9	5-7	X	X	X	X	X	X	X	X	X			X	X	X	X	X	X		1972
Sunset	35-43	50-60	23-29	17-21	X	X	X	X	X	X	X	X	X	X	X	X	X	X	X	X	X	X	1957
Sweet Pea	15-19	20-24	9-11	5-7							X	X	X										
Swing Time	15-19	20-24	9-11	5-7	X	X	X	X	X	X	X	X	X	X	X	X	X	X	X	X	X		1959
Sycamore	15-19	20-24	9-11	5-7	X	X	X	X	X	X	X	X	X	X	X	X	X	X	X	X	X		1958
Tahiti	18-22	23-29	10-12	7-9	X	X	X	X	X	X	X	X	X			X	X	X	X	X			1965
Tahoe	18-22	23-29	10-12	7-9	X	X	X	X	X	X	X	X	X	X	X	X	X	X	X	X	X		1950
Talisman	23-29	32-40	14-18	11-13	X	X	X	X	X	X	X	X	X	X	X	X	X	X	X	X	X		1961
Tangier	18-22	23-29	10-12	7-9	X	X	X	X	X	X	X	X	X	X	X	X	X	X	X	X	X	X	
Tapestry	34-42	47-57	22-26	17-21	X	X	X	X	X	X	X	X	X	X	X	X	X	X	X	X	X	X	1959
Tara	24-30	35-43	16-20	12-14	X	X	X	X	X	X	X	X	X	X	X	X	X	X	X	X	X	X	1959
Teak	41-51	40-50	25-31	18-22	X	X	X	X	X	X	X	X	X	X	X	X	X	X	X	X	X		1952
Terra Cotta	18-22	23-29	10-12	7-9	X	X	X	X	X	X	X	X				X	X	X	X	X	X		1965
Tiempo, Apricot	15-19	20-24	9-11	5-7	X	X	X	X	X	X	X	X	X	X	X	X	X	X	X	X	X		1949
Tiempo, Coral/Tan	15-19	20-24	9-11	5-7	X	X	X	X	X	X	X	X	X	X	X	X	X	X	X	X	X		1949
Tiempo, Gray	15-19	20-24	9-11	5-7	X	X	X	X	X	X	X	X	X	X	X	X	X	X	X	X	X		1949
Tiempo, Lime Green	15-19	20-24	9-11	5-7	X	X	X	X	X	X	X	X	X	X	X	X	X	X	X	X	X		1949
Tiempo, Olive Green	15-19	20-24	9-11	5-7	X	X	X	X	X	X	X	X	X	X	X	X	X	X	X	X	X		1949
Tiempo, Terra Cotta/Dark Brown	15-19	20-24	9-11	5-7	X	X	X	X	X	X	X	X	X	X	X	X	X	X	X	X	X		1949
Toffee	15-19	20-24	9-11	5-7	X	X	X	X	X	X	X	X				X	X	X	X	X			
Tonquin, Brown	17-21	22-26	9-11	5-7	X	X	X	X	X	X	X	X	X			X	X	X	X	X	X	X	
Tonquin, Pink	18-22	23-29	10-12	7-9	X	X	X	X	X	X	X	X	X	X	X	X	X	X	X	X	X	X	
Topaz	17-21	22-26	9-11	5-7	X	X	X	X	X	X	X	X	X			X	X	X	X	X	X	X	1965
Trianon	22-28	30-36	15-19	10-12	X	X	X	X	X	X	X	X	X	X	X	X	X	X	X	X	X	X	1959
Trio	15-19	20-24	9-11	5-7	X	X	X	X	X	X	X	X	X	X	X	X	X	X	X	X	X	X	1954
Tulip	22-26	20-24	12-14	11-13	X	X	X	X	X	X	X	X	X	X	X	X	X	X	X	X	X		
Tuliptime	16-20	14-18	13-15	5-7	X	X	X	X	X	X	X	X				X	X	X	X	X	X	X	1963

156

Pattern Name	Dinner Plate	Cup & Saucer	Salad Plate	Bread & Butter Plate	Luncheon Plate	Creamer	Sugar Bowl	Oval Vegetable	Round Vegetable	Platters 10"-18"	Five Piece Place Setting	Fruit Bowl	Cereal Bowl	Soup Bowl	Cream Soup & Saucer	Gravy Boat	Butter Dish	Salt & Pepper	Teapot	Coffee Pot	Covered Vegetable	Demitasse	Date First Produced	
Twice Nice	14-18	19-23	8-10	4-6	X	X	X	X	X	X	X	X	X			X	X	X	X	X	X	X	1959	
Twilight	31-39	41-51	18-22	14-16	X	X	X	X	X	X	X	X	X	X	X	X	X	X	X	X	X	X		
Twilight Rose	36-44	25-31	22-26	14-18	X	X	X	X	X	X	X	X	X			X	X	X	X	X	X	X	1983	
Valencia	20-24	26-32	13-15	8-10	X	X	X	X	X	X	X	X	X	X	X	X	X	X	X	X	X	X	1959	
Viking	14-18	19-23	8-10	4-6	X	X	X	X	X	X	X	X	X	X	X	X	X	X	X	X	X	X		
Westwood	34-42	47-57	22-26	17-21	X	X	X	X	X	X	X	X	X	X	X	X	X	X	X	X	X	X	1942	
Wheat, Golden Brown	18-22	23-29	10-12	7-9	X	X	X	X	X	X	X	X	X	X	X	X	X	X	X	X	X	X		
Wheat, Green	18-22	23-29	10-12	7-9	X	X	X	X	X	X	X	X	X	X	X	X	X	X	X	X	X	X		
Wheat, Light Gold	18-22	23-29	10-12	7-9	X	X	X	X	X	X	X	X	X	X	X	X	X	X	X	X	X	X		
Whirl-A-Gig	14-18	19-23	8-10	4-6	X	X	X	X	X	X	X	X				X	X	X	X	X	X	X		
Wicker Weave	18-22	23-29	10-12	7-9	X	X	X	X	X	X	X	X	X	X	X	X	X	X	X	X	X	X		
Wild Flower	88-108	88-108	62-76	45-55	X	X	X		X	X	X	X	X			X			X			X	X	1942
Willow	31-39	41-51	18-22	14-16	X	X	X	X	X	X	X	X	X	X	X	X	X	X	X	X	X	X		
Willow Bouquet	31-39	41-51	18-22	14-16	X	X	X	X	X	X	X	X			X	X	X	X	X	X	X	X	1954	
Wilshire	31-39	41-51	18-22	14-16	X	X	X	X	X	X	X	X	X	X	X	X	X	X	X	X	X	X	1942	
Windemere	23-29	32-40	14-18	11-13	X	X	X	X	X	X	X	X	X	X	X	X	X	X	X	X	X	X		
Winsome	20-24	26-32	13-15	8-10	X	X	X	X	X	X	X	X	X	X	X	X	X	X	X	X	X	X	1958	
Winter Bouquet	31-39	41-51	18-22	14-16	X	X	X	X	X	X	X	X			X	X	X	X	X	X	X	X	1954	
Woodlore	15-19	20-24	9-11	5-7	X	X	X	X	X	X	X	X	X			X	X	X	X	X	X		1954	
Woodside	35-43	50-60	23-29	17-21	X	X	X	X	X	X	X	X	X	X	X	X	X	X	X	X	X	X	1941	
Zanzibar	15-19	20-24	9-11	5-7	X	X	X	X	X	X	X	X	X			X	X	X	X	X	X	X	1971	
Zinnea	15-19	20-24	9-11	5-7	X	X	X	X	X	X	X	X	X	X	X	X	X	X	X	X	X	X	1967	

157